Published in conjunction with the exhibition *Empire and Its Discontents* at the Tufts University Art Gallery, Medford, MA
September 11–November 23, 2008

The Tufts University Art Gallery animates the intellectual life of the greater university community through exhibitions and programs exploring new, global perspectives on art and on art discourse.

The Gallery fosters critical dialogue through exhibitions and programs that explore fresh interpretations and scholarship on art, that provide a forum for art produced internationally by emerging and mid-career artists, and that feature new work of established artists.

Designed by Paul Sheriff / Sheriff Design

Book illustrations pg 1, 10, 11, 26, 27, 68, 69 by Paul Sheriff

Printed and bound by The Imaging Group

Copyright © Trustees of Tufts College, 2008

ISBN: 1-880593-07-6

Library of Congress Cataloging-in-Publication Data

Schlegel, Amy Ingrid.
 Empire and its discontents / introduction and texts by Amy Ingrid Schlegel ; essay by Rhonda Saad.
 p. cm.
 Catalog of an exhibition at Tufts University Art Gallery, Medford, MA, Sept. 11-Nov. 23, 2008.
 ISBN 1-880593-07-6
 1. Art and society--History--21st century--Exhibitions. 2. Orientalism--Exhibitions. 3. Postcolonialism--Exhibitions. I. Saad, Rhonda, 1946- II. Tufts University. Art Gallery. III. Title.
 N72.S6S319 2008
 709.171'2--dc22
 2008030215

EMPIRE
AND ITS DISCONTENTS

Foreword and short essays by
Amy Ingrid Schlegel

Essay by
Rhonda Saad

Published by the
Tufts University Art Gallery
Medford, MA

TABLE OF CONTENTS

FOREWORD

Conceived as a tribute to the influential post-colonial theorist, comparative literature scholar, and Palestinian activist Edward Said (1935-2003) on the 30th anniversary of the publication of his watershed book *Orientalism, Empire and Its Discontents* extends Said's analytical principles and ideals into the 21st century and into the realm of contemporary art, neither of which was in his chosen discursive arena. *Orientalism* profoundly changed the discourse of art history and has influenced generations of artists who have come of age since its publication in 1978. This exhibition and publication explore Said's legacy in the work of ten contemporary artists who have familial and other ties to the "imaginative geographies" Said identified as "the Orient." Although

Said did not explicitly include Iran, India, or Pakistan in his terminology (since he was primarily engaged in an examination of European colonialism up through the 19th-century), we have included artists with ties to these countries as well as to North Africa and the Middle East.

Said's project with *Orientalism,* as he retrospectively defined it in the late 1990s, was not a defense of Islam nor an attack on "the West"; rather, as he explained it: "the whole argument of the book, and the laboriousness, to my mind, of its analyses, is to show the diversity of opinion, and the coalescence around a few ideas. But the diversity of expression and opinion in *Orientalism* is very important to the conception of it."[1] *Empire and Its Discontents* embraces Said's insistence on the peaceful–if not harmonious– coexistence of multiple voices and on counter-point (and the musical metaphor of contrapuntal voices) as leitmotifs.

"ETYMOLOGICALLY, THE WORD 'EMPIRE' DERIVES FROM THE LATIN *IMPERIUM*, WHICH EVOKES SUCH DEFINING TERMS AS SOVEREIGNTY OR RULE."

—Stephen Howe, Empire. A Very Short Introduction

Many artists working trans-nationally today wittingly or unwittingly embrace Saidian values in their visual investigations of contemporary culture. "Rather than trying to treat culture and cultural documents en masse," Said noted to an interviewer in 1994, "my whole method is really about close, scrupulous attention to each case, put . . . in its historical context, and above all trying to show how contradictory, both politically and aesthetically, these documents are. Because the nature of culture itself is diversity and hybridity and mixture, rather than one thing."[2] *Orientalism* and subsequent publications by Said have given artists and other cultural practitioners permission to question and critique the gap between representation and lived experience, between official and unofficial histories, between collective and individual struggles, between the embrace of cosmopolitanism as an ideal and the disconcerting reality of moving among, and living in, different cultures. The artists in this exhibition explore all of these tensions in funny, serious, witty, and provocative ways.

Amy Ingrid Schlegel, director of galleries and collections, Tufts University
Co-curator of *Empire and Its Discontents*

1. Tariq Ali, *Conversations with Edward Said* (New York: Seagull Books, 2006), 100.
2. Ali, 103.

ACKNOWLEDGMENTS

This project is a perfect manifestation of the Tufts University Art Gallery's mission of exploring new, global perspectives on art and art discourse and a successful example of co-curating between a Gallery Director/Curator and a graduate student, between a seasoned curator and an emerging curator. I invited Rhonda Saad to develop with me the ideas and thesis that have become *Empire and Its Discontents* while enrolled at Tufts, knowing of her plans to specialize in the burgeoning field of contemporary art of the Arab world. Saad is continuing her studies in the Ph.D. program in art history at Northwestern University. I would like to thank her for making the curatorial process such an intellectually stimulating adventure, for indeed, the process took twists and turns that we could not have anticipated when we began in the fall of 2007.

Rhonda Saad wishes to thank Sarah Rogers for her keen eye and theoretical insight.

We gratefully acknowledge the artists, dealers, and collectors who contributed toward bringing this exhibition to fruition:

✤ Kamrooz Aram for his spirited discussion of *Orientalism* at work in the world today; Caroline Dowling, director of the Perry Rubenstein Gallery, New York; Todd Levin and Sarah Aibel of the Sender Collection, New York.

✤ Andisheh (Andy) Avini for his generosity of time; and Jonathan Lavoie at I-20 Gallery, New York.

✤ Lara Baladi for her responsiveness; Factum Arte, Madrid; and Sarah Parsons at The Blue Coat Gallery, Liverpool.

✤ Zoulikha Bouabdellah for her candor and style; and Celine Brugnon at La B.A.N.K., Paris.

✤ Kenneth Tin-Kin Hung for his no-holds-barred satirical wit; and Magdalena Sawon of Postmasters Gallery, New York.

✤ Farhad Moshiri and Shirin Aliabadi for their openness to dialogue; and Daneyal Mahmood and the Daneyal Mahmood Gallery, New York.

✤ Marjane Satrapi and Random House, Inc., for image permissions.

"EMPIRE: A LARGE, COMPOSITE, MULTI-ETHNIC OR MULTINATIONAL POLITICAL UNIT, USUALLY CREATED BY CONQUEST, AND DIVIDED BETWEEN A DOMINANT CENTRE AND SUBORDINATE, SOMETIMES FAR DISTANT PERIPHERIES."

—*Stephen Howe, Empire. A Very Short Introduction*

"EMPIRE: A STATE THAT EXTENDS DOMINION OVER POPULATIONS DISTINCT CULTURALLY AND ETHNICALLY FROM THE CULTURE/ETHNICITY AT THE CENTER OF POWER. . . . WHAT CONSTITUTES AN EMPIRE IS SUBJECT TO WIDE DEBATE AND VARIED DEFINITIONS." —*Wikipedia*

✤ Seher Shah for her earnestness and intensity; Sadia Rehman at Bose Pacia Gallery, New York; and the Shumita and Arani Bose Collection.

✤ Mark Shetabi for his clarity of purpose and love of realist painting; and to Jeff Bailey Gallery, New York.

✤ Saira Wasim for her scrupulousness; James Yohe of Ameringer & Yohe Fine Art, New York; and the private collectors: Kamran Anwar and Gayatri Chanana, London; Koli Banik and Erik Bertin, Alexandria, VA; I.H. Kempner, III, Houston, TX; Deborah and Peter Smith, Naples, FL; and an anonymous private collection, New York, NY.

We are also indebted to those academics and museum professionals who provided us guidance:

✤ Dr. Nada Shabout, visiting professor at MIT, and the graduate students in her spring 2008 course "Orientalism and Representation"

✤ Professors Eva Hoffman and Ayesha Jalal of Tufts University

✤ Dr. Massumeh Farhad, chief curator and curator of Islamic Art, Freer Gallery of Art and the Arthur M. Sackler Gallery, Smithsonian Institution, Washington, D.C.

✤ Dr. Woodman Taylor, assistant curator of Asian Art at the Museum of Fine Arts, Boston

I would like to thank the staff of the Tufts University Art Gallery for helping to realize this exhibition, publication, and interpretive planning: Jeanne V. Koles, for editorial and publication coordination; Doug Bell, for exhibition design and registration; Kristen Heintz-Perkins and Kathleen Smith for assistance with interpretive and cell-phone tour planning; Nina Bozicnik for coordinating our *Voice Your Vision!* (docent) program; and Paul Sheriff for designing another superb publication that embodies the exhibition's central concepts.

Lastly, publications like this one are made possible by the School of Arts and Sciences of Tufts University, by the Kenneth A. Aidekman Family Fund, and by our Contemporary Art Circle supporters—*thank you!*

— A.I.S.

9

抵港
Arrivals
離境
↑ Departu

EMPIRE AND ORIENTALISM

Rhonda Saad

Thirty years have now passed since Jean-Léon Gérôme's nineteenth-century painting *The Snake Charmer* first graced the cover of Edward Said's book *Orientalism* (fig. 1).[1] Art historians and cultural critics have contributed extensively to the field of post-colonial studies since *Orientalism*, unpacking related discourses on nationalism, globalism,and media theory, to name a few.[2] *Empire and Its Discontents* pays homage to many of the ideas articulated by Edward Said.

Beginning with the historical and cultural relationship between Europe and Asia, a relationship that, as Said noted, spans 4,000 years, *Orientalism* carefully outlines the deleterious effects of past European studies of a region that was collectively organized under the nineteenth-century label "Orient."[3] Said's interest in how cross-cultural knowledge is attained led to the formulation of his critique of modern empires and his often-cited thesis that the Orient was simply

> "THE ORIENT AND THE OCCIDENT ARE FACTS PRODUCED BY HUMAN BEINGS, AND AS SUCH MUST BE STUDIED AS INTEGRAL COMPONENTS OF THE SOCIAL, AND NOT THE DIVINE OR NATURAL, WORLD." —Edward Said, Orientalism Reconsidered

an "imaginative geography," a cultural construct conjured up by the self-interested colonial empires of Europe.[4] These ideological constructions produced images of a subordinate colonial "Other" that stood in direct opposition to the European "Self." The polarization of difference, which depended on essentializing diverse groups of colonial subjects, proved to be a potent political strategy to promote colonial agendas abroad and garner support in the metropole.

While *Orientalism* does not address the visual arts directly, art historians have borrowed from the ideological structure proposed by Said to examine the role of representation in the promotion of imperial agendas. Linda Nochlin, for example, posited that the popularity of French Orientalist paintings from the mid- to late-nineteenth century stemmed from Napoleon's Second Empire political aspirations rather than the Academy's concern with formal innovations in the arts.[5] Such romanticized and often fantastical images from the colonial era rendered the faraway territories as, among other things, ahistorical. Orientalist paintings like *The Snake Charmer* functioned to provide modern viewers with a photo-realist impression of an exotic, pre-colonial reality suspended in time. Such visual imagery also led audiences to believe that the vitality of these anonymous colonial subjects was contingent upon direct contact with imperial powers. Colonial involvement was not simply conceived of as a philanthropic, civilizing gesture of good faith but as an *essential* component in the survival and growth of overseas territories.

fig. 1 **Jean-Léon Gérôme**
The Snake Charmer, c. 1880 / Oil on canvas / 1955.51
© Sterling and Francine Clark Art Institute, Williamstown, Massachusetts

Shortly after World War I, the great Ottoman Empire, which at its height covered parts of North Africa, the Middle East, and southeastern Europe, fell, and the fragmented landscape was divided into distinct political entities during the interwar period.[6] By the mid-twentieth century, most of the colonies in these regions had achieved, or were on the cusp of achieving, independence from western powers. Independence promised to rid former territories of the formal presence of empire, but as historians and critics have argued, these formal empires of the past have been replaced by extant informal ones that operate equally dynamically in the contemporary context.[7]

Correcting a Distorted Lens

Cross-cultural exchange is a common and productive feature of empire, and the arts have historically served as one of the greatest agents for such exchange. In both pre-modern and modern instances of empire, artists have traveled in multiple directions and across vast distances to practice their respective trades. The rulers of the Kushan Empire (1st–3rd c. CE), for example, employed foreign artists trained in the Greco-Roman sculptural tradition throughout present-day Afghanistan, Pakistan, and northern India. The Gandhara style, as it is known today, is recognizable by its unique blend of local Indian styles and western classicism that was brought to the aforementioned regions from the eastern centers of the Roman Empire.[8] A more comprehensive study of empire would yield countless other examples of syncretism in the history of art and visual culture. This syncretism in the contemporary context sparked our interest to focus on emerging artists with ties to regions Said identified as the "Orient."

Empire and Its Discontents explores the dynamic role of representation in contemporary conceptions of empire. The artists in this exhibition are interested in reversing, or at the very least critiquing, the distorted lens, which Said identified as "Orientalism," through which difference and the "the Other" have been represented historically. Many of the artists pay tribute to Edward Said's legacy by exploring the effects of imperialism and the role of visual imagery in propagating empire.

One group of artists included in this exhibition is concerned with the physical and ideological effects of the European colonialism projects. Another group responds to perceived manifestations of empire in the contemporary context, notably in the form of political and cultural imperialism. A third group derives formal inspiration from artistic

traditions rooted in ancient and medieval empires. The artists in this group use appropriation strategies to initiate nuanced critiques of imperialist trends in representation itself. While the individual works differ greatly in style, media, content, and technique, they are connected by these thematic rubrics. And while these rubrics function as an organizational strategy, many of the works overlap thematically. We encourage viewers to identify and take note of the exchanges that occur between and among artists.

It became apparent early on in the curatorial process that a framework organized around national identity could not adequately support the multifarious responses that my co-curator and I perceived in works we considered. The artists in *Empire and Its Discontents* have had access to a seemingly boundless, virtual archive of digitized images and information via the Internet, to instantaneous exchange via e-mail, and to an ever-broadening array of mass and popular media– television, online news services, and video games–and they use all of these sources in the conception and production of their work. Furthermore, the emerging artists in this exhibition have all studied and/or lived in multiple metropolises. Their multi-directional perspectives reveal a much less constricting, more complex formulation of identity than what is made visible through a nationally-bounded lens. Forcing such a framework on the art muted the more subtle exchanges and quirky critiques that we found so engaging about the work in the first place.

Relics of Empire

One group of artists in this exhibition approaches the topic of empire by representing the collapse of colonial empire. **Seher Shah** exhibits an active interest in the aftermath of empire in her recent print series, *Perversions of Empire* (fig. 2, 41, and 42). Shah combines intricately rendered drawing with archival black and white photography to explore the role of colonial architectural markers that continue to occupy present-day urban spaces in India and Pakistan. Such markers include monuments erected by the British in colonial India that function today as traffic regulators, as well as perhaps less obvious markers, such as the enduring use of English street names to mark roads in the cantonment section, or foreign military district, of Lahore, Pakistan, the artist's hometown.

"...THE NATURE OF CULTURE ITSELF IS DIVERSITY AND HYBRIDITY AND MIXTURE..."[9] —*Edward Said*

14

fig. 2 **Seher Shah** *Perversions of Empire: The Concrete Oracles,* 2008
Archival giclée print / Edition of 10 / 18 x 24 inches
Courtesy of the Shumita and Arani Bose Collection, New York, NY

Seher Shah's sensitivity to architectural relics of empire is echoed in **Mark Shetabi's** installation project, *A Persian Garden.* The centerpiece of the installation is a scale-model sculpture of his family's central courtyard garden in Tehran, constructed initially from memory (figs. 44 and 45). The accuracy of the Modernist architectural forms of the fountain/swimming pool was confirmed by a handful of his mother's surviving photographic prints of her children at play there. The project was inspired by the artist's childhood between 1974 and 1978, when he was enrolled at The Tehran American School. He was one of the few American children of Iranian parentage to attend the school, otherwise populated by the children of American contractors, diplomats, and civilian advisors to the Shah's regime. He left when the doors closed in anticipation of the Iranian Revolution in 1979.

fig. 3 **Mark Shetabi**
Caspian Sea Hilton, 2008
Oil on linen
22 x 30 inches
Courtesy of the artist and
Jeff Bailey Gallery, New York

One of Shetabi's most potent memories of the school is his encounter there with a poster reproduction of Henri Rousseau's *The Sleeping Gypsy* (fig. 4). Paintings contained inside Shetabi's anonymous-looking domestically-scaled installation relate to Muhammad Reza Shah's modernization projects of the 1970s. For example, Shetabi paints his memory of childhood vacations spent in an American luxury hotel on the Caspian Sea constructed around the same time, which the artist remembers as always being empty (fig. 3). He also paints the F-14 Tomcat, built in partnership with U.S. military and government contractors residing in Iran in the same decade. Projects such as hotels and airplanes constitute what Shetabi considers a kind of empire building.

fig. 4 **Henri Le Douanier Rousseau, (1844-1910)**
The Sleeping Gypsy, 1897
Oil on canvas / 51 x 6' 7"
Gift of Mrs. Simon Guggenheim. (646.1939)
Location: The Museum of Modern Art,
New York, NY, U.S.A. / Photo Credit: Digital Image ©
The Museum of Modern Art/
Licensed by SCALA / Art Resource, NY

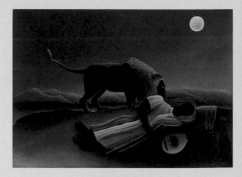

"THE VERY REASON FOR UNDERSTANDING THE ORIENT GENERALLY, AND THE ARAB WORLD IN PARTICULAR, WAS FIRST, THAT IT PREVAILED UPON ONE, BESEECHED ONE'S ATTENTION URGENTLY, WHETHER FOR ECONOMIC, POLITICAL, CULTURAL OR RELIGIOUS REASONS, AND SECOND, THAT IT DEFIED NEUTRAL, DISINTERESTED OR STABLE DEFINITION." —*Edward Said, Orientalism Reconsidered*

Lara Baladi's series of staged photographic diptychs, *Surface of Time*, (fig. 26) communicates the aftermath of colonial empire from a contemporary viewpoint located in present-day Egypt. Her interest in both social and political decay is captured in reflective photographs of dusty, broken objects and abandoned spaces in Cairo. Many of the objects were found in the *Souk El Goma* (Friday Market), which is located in an economically disadvantaged part of the city. The architectural backdrops for these objects recall spaces involved in outstanding property disputes, many of which have been lingering since 1952. That year marked the revolution in which Gamal Abel Nasser collaborated with Muhammad Naguib to overthrow King Faruq, the Egyptian monarch who many believed held pro-British sympathies.[10] The anti-colonial nationalist movement born in Egypt under Nasser provided fellow Arab nation-states with a unifying strategy designed to dissolve surviving traces of the former European empires. It would seem appropriate, therefore, that Baladi's series culminates in a rusted picture of current President Hosni Mubarak (fig. 5), who inherited the position after Nasser's successor, Anwar Sadat, was assassinated in 1981. To some citizens of the Arab states of the Middle East, the tarnished photograph of Mubarak must be a nostalgic reminder of the promise that the Nasser era once held for them in the 1950s and 1960s. In the contemporary context, however, the rusted surface is more likely read as a metaphor for Mubarak's unpopular government, commonly described by scholars in terms such as "stale-mate, stagnation, corruption, and authoritarianism."[11]

fig. 5 **Lara Baladi**
Surface of Time, 2004-2007
Permanent pigment print on Somerset paper
19 3/16 x 29 1/2 inches
Courtesy of the artist

Critiquing Contemporary Empire

Another group of artists in *Empire and Its Discontents* responds to one critic's question: "Do. . .transnational companies, financial and media institutions, or most broadly the forces of 'globalization', constitute a new imperial system?"[12] We might recognize affirmation to such a question in **Farhad Moshiri** and **Shirin Aliabadi's** *Supermarket* series of color photographs. Here the Iranian artists arrange everyday objects in squeaky-clean, vivid compositions that remind us of kitschy magazine or television advertisements. Recognizable commodities have been stripped of their original brand-name labels and provided with new, politically potent ones such as in *We Are All Americans* (fig. 6). The traditional empire defined by the imperialist rule of one nation over another is replaced by a new "brand" of empire defined by the power of the global economy and the few political and economic forces that control it. Such images may implicate a new world empire that is based on economic, political, cultural and/or media motivations. Contemporary Marxist philosophers Michael Hardt and Antonio Negri, in their 2000 book *Empire*, are critical of what they view as the reappearance of an economically injurious, global model of empire that they believe has been "the author of direct and brutal imperialist projects, both domestically and abroad."[13] Moshiri and Aliabadi seem to point to the supermarket as a metaphor for this new form of empire.

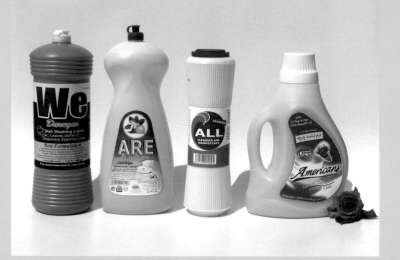

fig. 6 **Farhad Moshiri / Shirin Aliabadi**
We Are All Americans, 2005
Lambda print / 29 ½ x 39 ⅗ inches
Courtesy of Daneyal Mahmood Gallery, New York, NY

"AND FAR FROM BEING RIGHT, I THINK IT'S IMPORTANT TO BE CRITICAL. AND I'VE ALWAYS BEEN CRITICAL. . ."[14]
—Edward Said

fig. 7 **Kenneth Tin-Kin Hung**
Gas Zappers, 2007 / Music by Noah Vawter / HD video, 5 minutes
Edition of 5 +AP / Courtesy of Postmasters Gallery, New York, NY

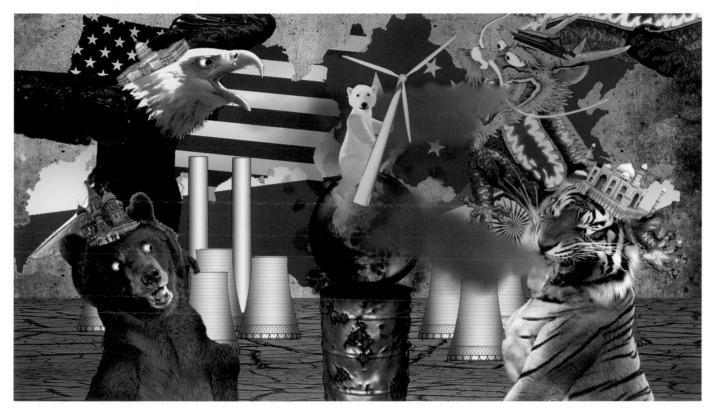

79

Similarly, **Kenneth Tin-Kin Hung** creates bright, saturated montages that juxta-pose up-to-the-minute, pertinent political images and figures such as Barack Obama and John McCain with American pop culture icons like Oprah Winfrey and Britney Spears (figs. 30 and 31). Hung's digitally montaged "pop-up" sculptures and video, *Gas Zappers* (fig. 7), are unavoidably in-your-face, and like Moshiri and Aliabadi, Hung appropriately utilizes humor as a tempering device. Moshiri/Aliabadi's and Hung's works are visually arresting and challenging. They unavoidably trigger debate among viewers regarding the current state of American political, economic, social, and environmental policies.

"THE IMAGINATIVE EXAMINATION OF THINGS ORIENTAL WAS BASED MORE OR LESS EXCLUSIVELY UPON A SOVEREIGN WESTERN CONSCIOUSNESS OUT OF WHOSE UNCHALLENGED CENTRALITY AN ORIENTAL WORLD EMERGED, FIRST ACCORDING TO GENERAL IDEAS ABOUT WHO OR WHAT WAS AN ORIENTAL, THEN ACCORDING TO A DETAILED LOGIC GOVERNED NOT SIMPLY BY EMPIRICAL REALITY BUT BY A BATTERY OF DESIRES, REPRESSIONS, INVESTMENTS, AND PROJECTIONS."

–Edward Said, *Orientalism*

The four verses of the Star-Spangled Banner are the soundtrack for **Zoulikha Bouabdellah's** *Black and White #2* (fig. 8) in which a Lebanese performer is positioned in front of moving satellite maps of Baghdad and other Iraqi cities. Her body is relatively static with the exception of her hand movements, which according to Bouabdellah, recall the symbolic hand gestures of the wildly popular Egyptian singer Umm Kulthoum (1904-1975) as well as the ritualistic gestures used by Muslims in prayer. Her nails are brightly painted in stars and stripes, her long black hair is unconstrained by a veil, and her voice projects lines from the U.S. national anthem that are not commonly memorized or recited. The last verse, which in the video is organized as the second verse, is sung, according to the artist, like a lullaby in a generic Arabic accent.

The military satellite images, coupled with the hand gestures and fingernails painted like parts of a flag, function together to destabilize the meaning of the original lyrics. Viewers are forced to rethink the meaning of the anthem in this new, critical context.

Marjane Satrapi's graphic novels reflect critically on the successional development of empire from an autobiographical perspective. One page enlarged for this exhibition offers an abbreviated chronology of empire in Iran, beginning with the ancient Persian Empire, followed by successive registers depicting the Arab and Mongol invasions.

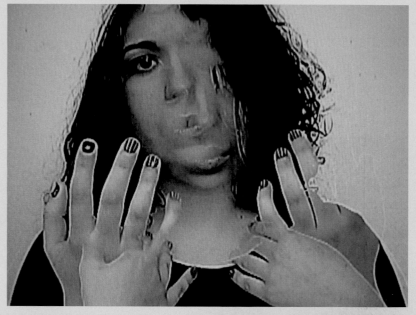

fig. 8 **Zoulikha Bouabdellah**
Black and White #2, 2008
Video, 6 minutes, 25 seconds
Courtesy of the artist and La B.A.N.K. Gallery, Paris

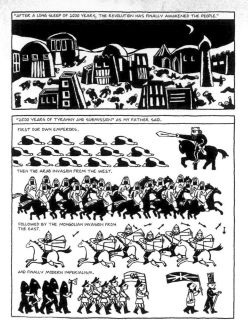

fig. 9 **Marjane Satrapi**
From *Persepolis: The Story of A Childhood*
by Marjane Satrapi, translated by Mattias Ripa
and Blake Ferris, page 11

The final register contains a parade of "modern imperialism" lead by Uncle Sam and a British flag bearer.[15] The mass-produced comic book format functions well as an agent for cross-culturalism and exchange. The images in *Persepolis: The Story of a Childhood*, (fig. 9) from which this page is taken, have traveled to various corners of the world through their translation into multiple languages and also their adaptation into an animated film.

Historical Returns: Appropriation as a Critical Strategy

A significant number of the works exhibited in *Empire and Its Discontents* are undoubtedly explicit in their critique of empire. The third rubric, however, includes works that articulate discontent in a more nuanced manner. For this group, technique holds as privileged a position as content or subject matter. **Saira Wasim**, **Andisheh Avini**, and **Kamrooz Aram** use appropriation as a formal and theoretical strategy to challenge the ways in which "traditional" art forms from the "Orient" have remain fixed categories in the contemporary museum-goer's imagination.[16] These works juxtapose "traditional" techniques with "novel" subject matter, thus blurring the rigidly defined categories we have come to expect from the art historical discourse. In a way, the artworks in this group most directly mobilize the tools outlined by Edward Said to confront eurocentricity in the art historical canon, and by extension, audience expectations of representation in the museum context.

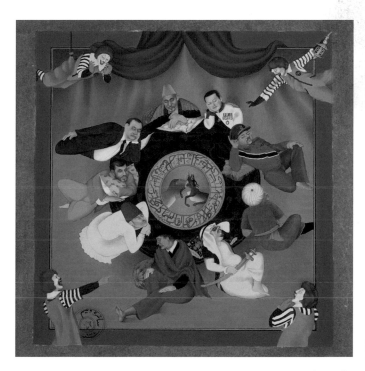

fig. 10 **Saira Wasim**
Round Table, 2005
Gouache, gold leaf, and ink on tea stained wasli paper
17 x 18 inches
The Anwar Family Collection, London
Courtesy of Ameringer & Yohe Fine Art, New York, NY

Saira Wasim faithfully employs the Mughal painting technique of applying pigment to *wasli*, or layered rag paper, and maintains an allegiance to the miniature-sized format, even while she subverts traditional subject matter. Mughal miniature paintings from the sixteenth and seventeenth centuries traditionally contained scenes of battle, the hunt, and royal portraits designed to glorify the ruler and members of the imperial court. Wasim appropriates many of these same stage sets, but replaces the Mughal-era charac-ters with a contemporary cast of political celebrities and clowns. The miniature painting format requires viewers to be drawn in closely; when the content is brought into focus, the viewer's expectations for medieval rulers are suddenly overturned when George W. Bush and Condoleezza Rice appear in their stead. Wasim's 2005 miniature painting *Round Table* depicts recognizable world leaders sound asleep at a table surrounded by animated Ronald McDonald figures (fig. 10). Recognizable American and European heads of state are noticeably absent from the

international gathering, lending the conclusion that the plotting clowns occupying the four corners of the stage perform as stand-ins for American interests and, by extension, those of its European allies. Wasim's critique of current global politics satirizes both current leaders of Middle Eastern and Islamic states as ineffective and American power as clownish.

Similarly, **Andisheh Avini** appropriates the ancient Persian art of *Khataam* (wood inlay) marquetry to cover the surface of sculptural forms. This technique, typically used to embellish decorative and functional wooden objects, is employed here to cover the plastic surface of a souvenir Statue of Liberty. Avini's *Homesick* (fig. 11) fuses a revered Persian art form and a banalized yet still potent symbol of America to underscore his uncertainty about where his cultural and patriotic loyalties should lie as a bicultural Iranian-American. Avini's assisted ready-made sculptures, like **Zoulikah Bouabdella's** videos, ex-plore the mutation of cultural forms through unlikely, discomfiting juxtapositions.

Kamrooz Aram is also interested in toying with audience expectations by leaving open the meaning of the iconography in his paintings. *Mystical Visions Undetected by Night Vision Strengthen the Faith of the Believers and Make Their Enemies Scatter II* (fig. 12) depicts a fantastical environment set against a craggy, watery background and placed on a camouflaged ground. The iconography lacks distinct temporal/spatial markers and the ambiguous identification and placement of these signs challenges our often presumptuous or fixed way of seeing. For some viewers, the bird in the painting, for example, might instantly evoke the image of a bald eagle, the American symbol of power and authority. For others, the bird might be understood as a hawk and might recall the age-old sport of falconry that originated in Mesopotamia in the eighth century BCE.

A different kind of ambiguity is at play in Aram's drawing, *From the series Revolutionary Dreams* (fig. 15). The artist cast a group of anonymous revolutionary types from South America, Africa, and Asia and organized them along the peripheries of the drawing. The revolutionary leaders are connected to their followers by a delicately rendered, engulfing network

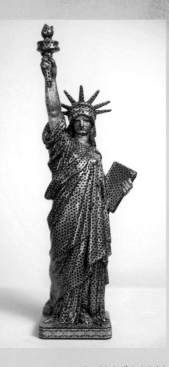

fig. 11 **Andisheh Avini**
Homesick, 2007
Plaster and Khataam (marquetry)
20 x 5 x 5 inches
Courtesy of the artist
and I-20 Gallery, New York, NY

of lines emanating from their open mouths. The ambiguous figures lack individual identities, yet their respective spirits are linked by a colorful web of speech to a common stimulus, that of the fair-featured figure occupying the central position on the page.

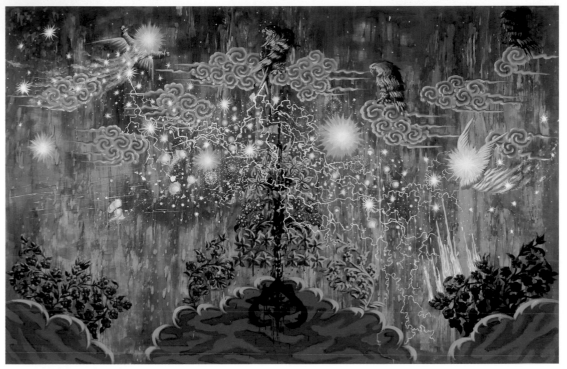

fig.12 **Kamrooz Aram**
Mystical Visions Undetected by Night Vision Strengthen the Faith of the Believers and Make Their Enemies Scatter II, 2007
Oil and collage on canvas
73 x 113 inches
The Sender Collection,
New York, NY
Image courtesy of the artist
and Perry Rubenstein Gallery,
New York, NY

In addition to the themes explored above, *Empire and Its Discontents* encourages reflection on the ethical dimension of representation in the global contemporary art context. As the work in this exhibition illustrates, the rigid binary oppositions introduced by Edward Said three decades ago, such as Self/Other, East/West, Orient/Occident, have been integrated into a vastly more complicated field of visual and cultural representation massively impacted by the proliferation of digital technologies, mass media, and popular culture. As many of the participating artists have articulated, alterity is not something to be diffused or shied away from; however, difference should be distinguished so long as it can be presented as a non-hierarchical relationship. Likewise, ambiguity has a place in the exhibition context, for it affords viewers the opportunity to derive meanings according to the unique cultural lexicon that each person brings to the work. Our goal was not to propose neatly packaged solutions to the broad questions about empire, globalization, and power structures that scholars continue to debate today. Rather, our goal was to offer viewers an open, but structured forum through which they might discover their own delights or discontents with the rich range of artistic responses presented in this exhibition.

ENDNOTES

1. Edward W. Said, *Orientalism,* (New York: Vintage Books, 1979). *Orientalism* was originally published by Pantheon Books in November 1978.

2. This list is, of course, extensive, but includes: Benedict Anderson, *Imagined Communities* (London: Verso Books, 1991); James Elkins, ed., *Is Art History Global?* (New York; London: Routledge, 2006); Maria Fernandez, "Postcolonial Media Theory," in *The Feminism and Visual Culture Reader*, 520-528 (London; New York: Routledge, 2003); Eric Hobsbawm and Terence Ranger, eds., *The Invention of Tradition* (Cambridge: Cambridge University Press, 1983).

3. The Orient, as discussed in *Orientalism,* is limited in scope to the region of the Middle East. Said's later work, *Culture and Imperialism*, 1st ed. (New York: A.A. Knopf, 1993), expands on his earlier thesis to include relationships between Europe and colonial territories spanning parts of Africa, India, the Caribbean, and Australia. Edward Said, "Orientalism Reconsidered," *Race & Class* 27, no. 2 (Autumn, 1985), 2.

4. Said, *Orientalism*, 49-72.

5. Linda Nochlin, "The Imaginary Orient," in *The Politics of Vision* (New York: Harper & Row, 1989), 33-59.

6. William L. Cleveland notes the emergence of Turkey, Syria, Lebanon, Palestine, Iraq, Transjordan, Saudi Arabia and Yemen in the aftermath of WWI in *A History of the Modern Middle East*, Third Ed. (Boulder: Westview Press, 2004), 171. See pages 43 and 159 for maps of territories held by the Ottoman Empire in the late sixteenth and early twentieth centuries respectively.

7. Stephen Howe, *Empire. A Very Short Introduction* (New York: Oxford University Press, 2002). For additional studies, see, for example, David B. Abernethy, *The Dynamics of Global Dominance* (New Haven and London: Yale University Press, 2000); Susan E. Alcock et al, eds., *Empires* (Cambridge: Cambridge University Press, 2001); Michael W. Doyle, *Empires* (Ithaca: Cornell University Press, 1986); Michael Hardt and Antonio Negri, *Empire* (Cambridge: Harvard University Press, 2000).

8. John M. Rosenfield, *The Dynastic Arts of the Kushans* (Berkeley; Los Angeles: University of California Press, 1967), for an in-depth historical analysis of the Gandhara style.

9. Tariq Ali, *Conversations with Edward Said* (New York: Seagull Books, 2006), 103.

10. Cleveland offers an account of the revolution of 1952 and the subsequent age of Nasserism in chapters fifteen and sixteen in *A History of the Modern Middle East*. According to Cleveland, "During the period from 1952 to 1967, Gamal Abd al-Nasser was the embodiment of what the Arab world wanted to be: assertive, independent, and engaged in the construction of a new society freed of the imperial past and oriented toward a bright Arab future." 301.

11. Cleveland, 533.

12. Howe, 6.

13. Hardt and Negri, 176-177.

14. Ali, 101.

15. Marjane Satrapi, *Persepolis: The Story of a Childhood* (New York: Pantheon Books, 2004), 11.

16. Hobsbawm, 1. Hobsbawm defined the role of invented traditions in the promotion of the modern nation-state: "'Invented tradition' is taken to mean a set of practices, normally governed by overtly or tacitly accepted rules and of a ritual or symbolic nature, which seek to inculcate certain values and norms of behaviour by repetition, which automatically implies continuity with the past."

"THE ORIENT WAS NOT EUROPE'S INTERLOCUTER, BUT ITS SILENT OTHER."

—Edward Said, Orientalism

KAMROOZ ARAM

Kamrooz Aram's lush, large-scale paintings are like riddles: one has to look long and think hard about the heterogeneous imagery populating his seemingly imaginary nocturnal landscapes. His recent, carpet-size paintings combine identifiable motifs (eagles, camouflage pattern, stylized flowers, a dove, and an angel) with abstracted motifs (astral bursts, flames, and cloud swirls) over a mottled, yet flattened expanse of green hues. "I became increasingly interested in how an audience perceives familiar and unfamiliar symbols and icons" after reading Edward Said's *Orientalism* in college in the mid-1990s. "I use symbols in a manner that I hope raises questions about our expectations of them," he says. Aram is a native of Shiraz, Iran, born on the eve of the Islamic Revolution, in 1978, who has lived in the U.S. since he was a child. Said's book influenced Aram to think about how distorted Western perceptions of

the East could be challenged by an ingenious subversion of iconography from different pictorial traditions. Aram appropriates from both Eastern and Western cultural traditions and overlays contemporary military and technological references (especially infra-red night vision) with flattened video-game space.

Aram's work is both politically engaged and aesthetically ambivalent about the notion of beauty. In his intricate large- and small-scale drawings he chooses to represent types of revolutionary and spiritual figures (Shiite clerics, African-American Black Power leaders, turbaned Ayatollahs, muhlas, or warlords for example) whose rhetoric fills the visual field and is represented by decorative foliage, floral, and flame-like patterns and pleasing color combinations. Aram's artistic project aims to represent no less than the current state of

the world—what he calls Empire as a dominant, but no longer geographically-definable, power—within the material boundaries of the canvas or paper field. His project assumes that the act of visual interpretation—sustained looking—should raise difficult questions, not provide facile answers, and reflect the complexity and conundrums of living in the 21st century.

— *A.I.S.*

Kamrooz Aram *was born in Shiraz, Iran in 1978 and moved to the United States at age eight. He received his BFA from the Maryland Institute College of Art and his MFA from Columbia University. His work has been exhibited at MassMoCA in North Adams, MA; the San Antonio Museum of Art; the Fullerton Art Museum; P.S. 1 MoMA; and Oliver Kamm/5BE Gallery in New York City. He is represented by the Perry Rubenstein Gallery, New York. The artist lives and works in Brooklyn, New York.*

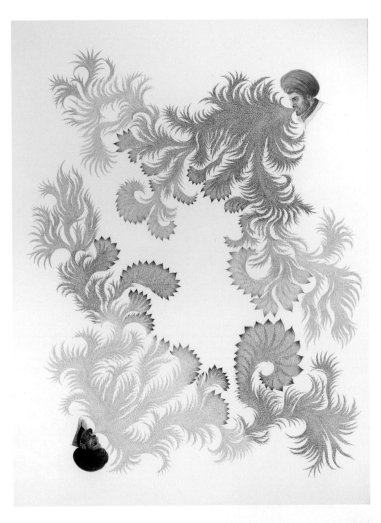

fig. 13 **Kamrooz Aram**
From the series Revolutionary Dreams to the series Mystical Visions and Cosmic Vibrations (and back again), or Radical Shia Cleric, or Spiritual Leader 2008
Ink on paper / 41 ¹/₂ x 30 ¹/₂ inches
Collection of Ikkan Sanada, New York, NY
Image courtesy of the artist and
Perry Rubenstein Gallery, New York, NY

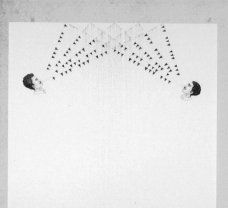

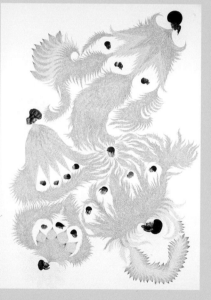

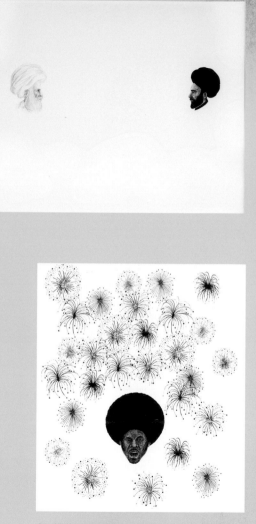

fig. 14 **Kamrooz Aram**
From the series Irrational Exuberance, 2007
Pen on paper / 14 ¹/₂ x 10 ¹/₂ inches
Courtesy of the artist and the
Perry Rubenstein Gallery, New York, NY

fig. 16 **Kamrooz Aram**
From the Series Mystical Visions and Cosmic Vibrations
to the series Revolutionary Dreams, 2007
Ink on paper / 14 ³/₄ x 18 ³/₄ inches
Courtesy of the artist and the
Perry Rubenstein Gallery, New York, NY

fig. 15 **Kamrooz Aram**
From the series Revolutionary Dreams, 2007
Pen on paper / 44 x 30 ¹/₄ inches
The Sender Collection, New York, NY
Image courtesy of the artist and the
Perry Rubenstein Gallery, New York, NY

fig. 17 **Kamrooz Aram**
From the series Revolutionary Dreams, 2007
Ink on collage on paper / 13 x 10 ¹/₂ inches
Courtesy of the artist and the
Perry Rubenstein Gallery, New York, NY

ANDISHEH AVINI

Andisheh Avini's monoprints, découpage and marquetry sculptures explore ideas of cultural overlays and effacements. He appropriates ancient Persian source material in his monoprints and artistry techniques in his sculptures. Rather than recreating these ancient sources or learning the decorative technique himself, he scans (for example in three untitled prints (figs. 23, 24, and 25), kitsch versions of Persian coffeehouse paintings of pre-Islamic mythological scenes (paintings he grew up with in his parents' home in Brooklyn) and then stains the portion of the images with religious and spiritual figures with bleach, in a mock gesture of iconoclasm (referring to the Muslim prohibition against figurative representation). The effacement technique of staining is reversed in other altered prints such as *Untitled (XXIX)* (fig. 20) in which a Persian miniature painting is scanned, enlarged, printed, and then painted with gold leaf to efface the identification of all the figures.

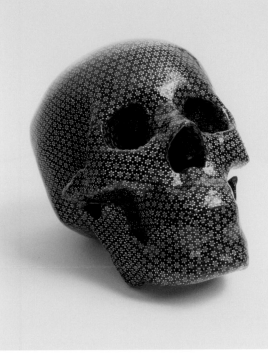

fig. 19 **Andisheh Avini**
Untitled, 2007
Plastic skull and Khataam (marquetry) / 6 x 9 x 5 inches
Courtesy of the Collection of Beth Rudin DeWoody

fig. 18 **Andisheh Avini**
Untitled, 2007
Paper Collage / 30 x 22 ¾ inches
Courtesy of the artist and
I-20 Gallery, New York, NY

Avini's sculptures visualize the effects of cultural exchange by overtly combining disjunctive cultural signifiers, such as the Statue of Liberty and the *Khaatam* (wood inlay) marquetry technique practiced for centuries in Isfahan, Iran (fig. 11). The resulting hybrid object may be an expression of pride in the artist's bicultural identity as Persian American, or it may represent a conflicted gesture about where his sympathies should lie. Another similarly decorated work employing a smaller-than-life-size human skull (fig. 19) transforms this classic, western symbol of death into an essentialized representation of the human form and into a wondrous, non-functional object of contemplation. An untitled découpage sculpture (fig. 21) fuses another multivalent symbol, also employed by Kamrooz Aram, (of either a bald eagle or hawk) with a conglomeration of mono-chromatic Orientalist representations of male and female figures. Avini's sculpture and painted prints explore, like Zoulikha Bouabdellah's video, the mutation of cultural forms through unlikely, discomforting overlays.

— A.I.S.

Andisheh Avini was born in New York City in 1974 and attended Hunter College. His work has been exhibited recently at the Aidan Gallery, Moscow; I-20 Gallery in New York; P.S. 1 Contemporary Art Center; and the Gagosian Gallery, New York. He is represented by I-20 Gallery and lives and works in New York.

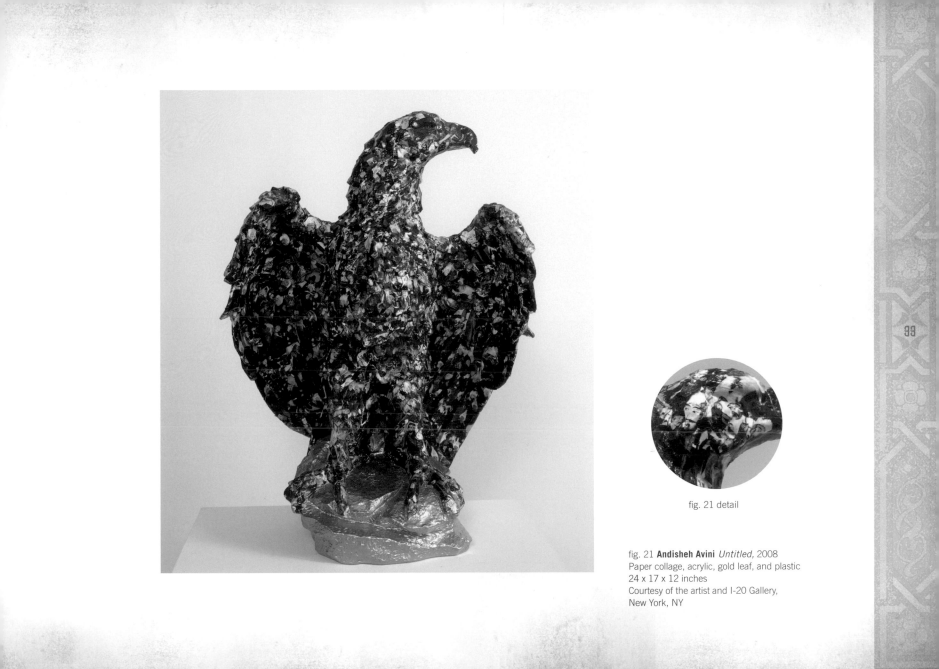

fig. 21 detail

fig. 21 **Andisheh Avini** *Untitled,* 2008
Paper collage, acrylic, gold leaf, and plastic
24 x 17 x 12 inches
Courtesy of the artist and I-20 Gallery,
New York, NY

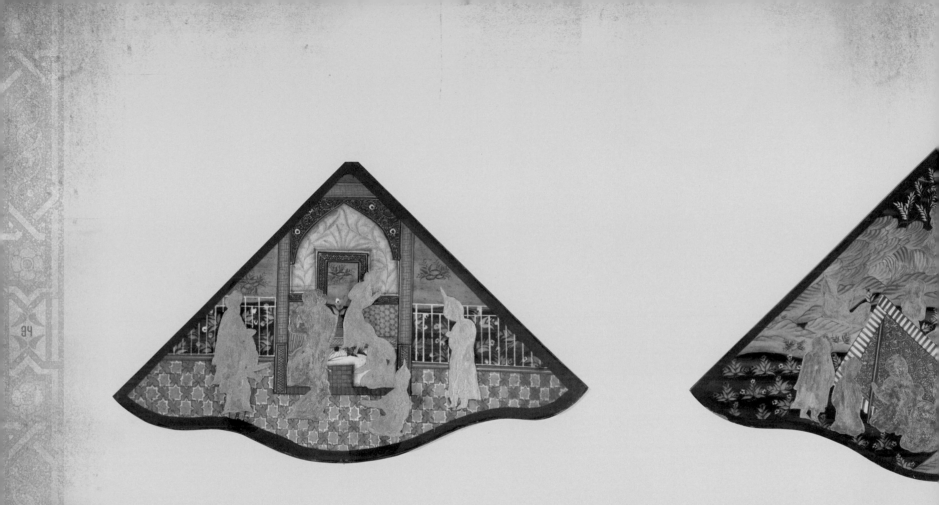

fig. 22 **Andisheh Avini** *Untitled*, 2007
Gold leaf and inkjet print on paper mounted to wood
Triptych, 14 1/4 x 21 inches each
Courtesy of the artist and I-20 Gallery,
New York, NY

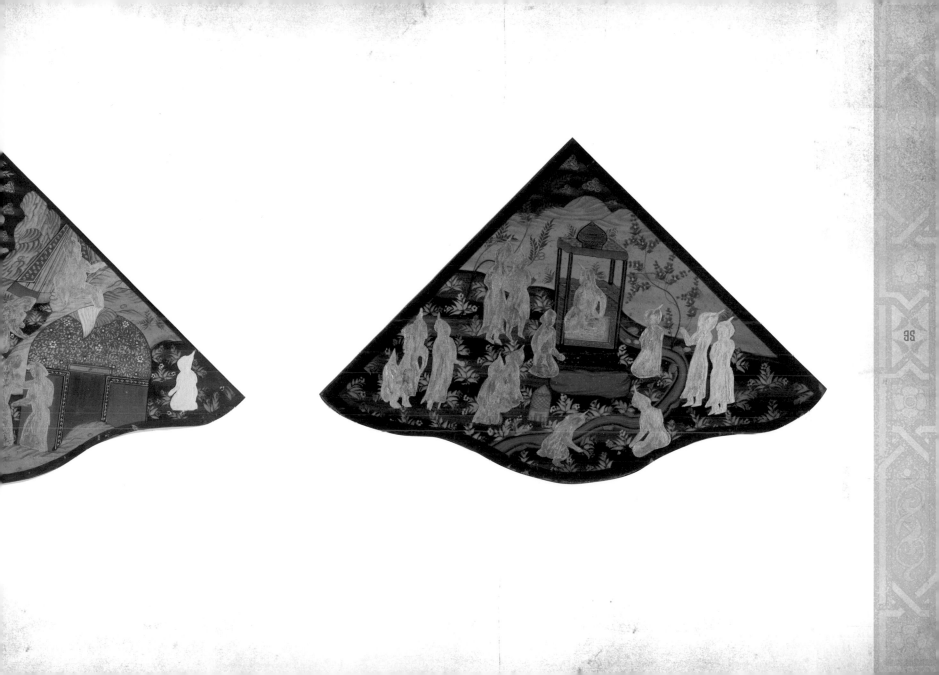

fig. 23 **Andisheh Avini** *Untitled (I)*, 2006
Bleach, gold leaf, and inkjet print on canvas
38 ³⁄₄ x 56 ³⁄₄ inches
Courtesy of the artist and I-20 Gallery, / New York, NY

fig. 24 **Andisheh Avini** *Untitled (V)*, 2006
Bleach, gold leaf, and inkjet print on canvas
45 ¹⁄₂ x 29 inches
Courtesy of the artist and I-20 Gallery, New York, NY

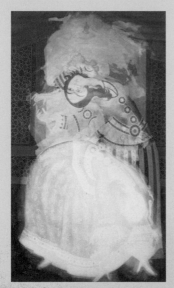

fig. 25 **Andisheh Avini** *Untitled (II)*, 2006
Bleach, gold leaf, and inkjet print on canvas
46 ³⁄₄ x 26 ³⁄₄ inches
Courtesy of the artist and I-20 Gallery, New York, NY

LARA BALADI

Lara Baladi's photographic series *Surface of Time* ruminates on what she calls the "post-apocalyptic state" of Egypt during the more than 25-year rule of President Hosni Mubarak. Read as a storyline, chronicling the decay and decline of Egypt since the revolution that brought Mubarak to power, Baladi's sometimes disjunctive pairing of images in this series combines public and private spaces, exterior and interior scenes to comment quietly on the social and political stagnation symbolized by abandoned apartments, faded wallpaper, broken, dusty, tarnished, and rusted objects, and religious graffiti. These photographs foreground absence, stagnation, and ruin in an un-nostalgic way; they represent the unfulfilled promises and faded glory of Empire, and implicitly, its hoped-for imminent collapse.

— *A.I.S.*

Lara Baladi *was born in Lebanon in 1969 to Lebanese-Egyptian parents. She has lived in Beirut, Paris, London, and, since 1997, in Cairo. She received a B.A. from Richmond University, London in 1990. Her work was included in the traveling exhibition* Snap Judgments: New Positions in Contemporary African Photography (2006-2008), *organized by the International Center for Photography, New York, and is in the collections of the Fondation Cartier, Paris, Museet for Fotokunst, Copenhagen, and the Pori Art Museum, Finland. She participated in Art Dubai and the Sharjah Biennial in 2007. Baladi is represented by the Townhouse Gallery, Cairo, Brancolini & Grimaldi Gallery, Rome, and B21 Gallery, Dubai, UAE.*

fig. 26 **Lara Baladi** *Surface of Time*, 2004-2007 / Permanent pigment print on Somerset paper / Eight diptychs / 19 $^3/_{16}$ x 29 $^1/_2$ inches each / Courtesy of the artist

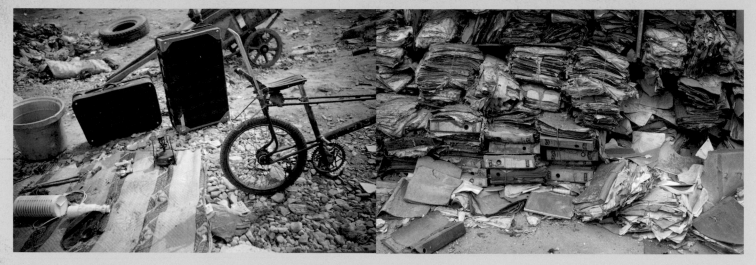

Lara Baladi *Surface of Time*

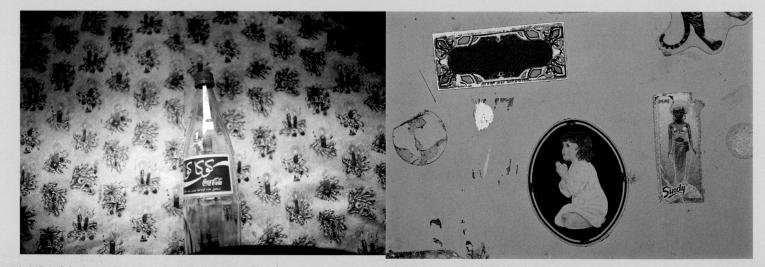

Lara Baladi *Surface of Time*

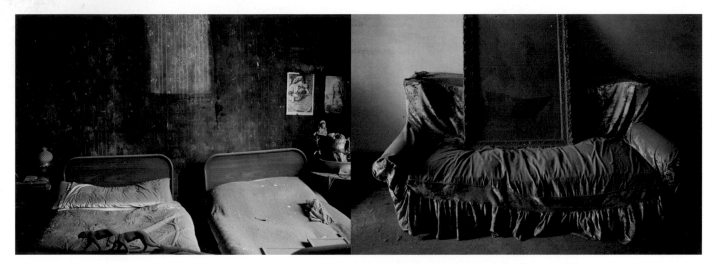

Lara Baladi *Surface of Time*

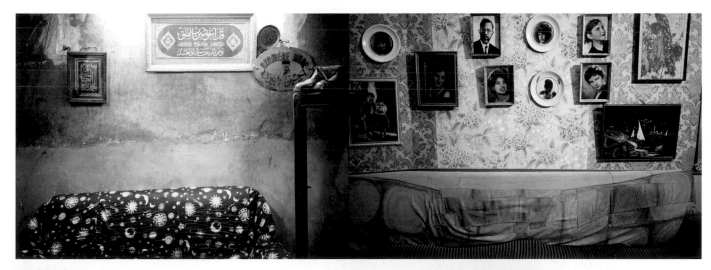

Lara Baladi *Surface of Time*

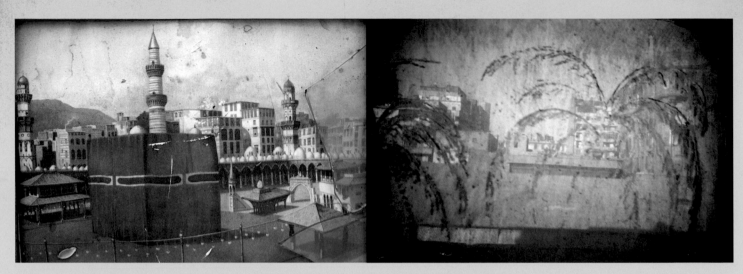

Lara Baladi *Surface of Time*

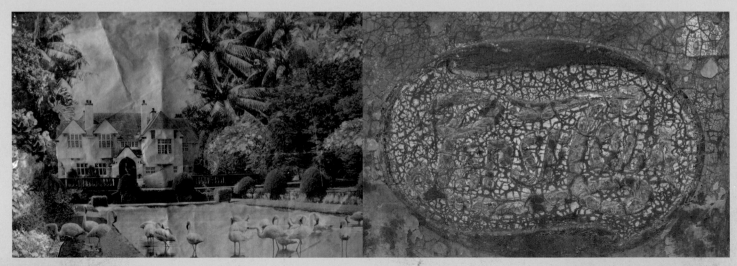

Lara Baladi *Surface of Time*

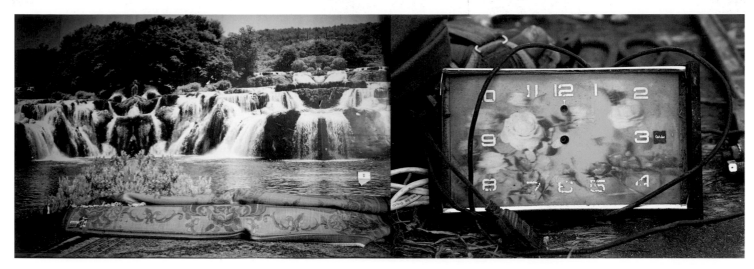

Lara Baladi *Surface of Time*

Lara Baladi *Surface of Time*

ZOULIKHA BOUABDELLAH

Video artist Zoulikha Bouabdellah is interested in representing the transmutation of cultures in the post-post-colonial era. Her new video installation *Black and White #2* layers several, disjunctive strains of imagery and sound to create a disquieting meditation on the conflation of cultures, religions, and geographies. An unveiled Arab woman languidly (or perhaps dolefully) sings the American national anthem in Arabic-accented English while making customary Muslim prayer gestures with her hands. Behind the monumentally-scaled figure flows a series of aerial maps (from Google Earth™) that, upon close looking, reveal themselves to be of Baghdad and other areas in Iraq. As with her earlier video *Dansons (Let's Dance)*, in which the camera focuses on the abdominal area of a belly-dancer wearing white, blue, and red performing to the French national anthem, one wonders which cultural influence (American or Middle Eastern) is being subverted in this unlikely composite, or whether a new, uncomfortable sort of hybrid is envisioned. *Black and White #2* suggests that both American nationalism and Muslim piety have been compromised in this curious conjunction of performed and digitally altered imagery.

— A.I.S.

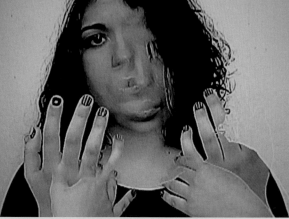

figs. 27 and 28 **Zoulikha Bouabdellah** *Black and White #2*, 2008
Video, 6 minutes, 25 seconds
Courtesy of the artist and La B.A.N.K. Gallery, Paris

French-Algerian artist **Zoulikha Bouabdellah** *was born in Moscow, Russia in 1977 and grew up in Algiers, Algeria, where her mother was a curator at the Musée des Beaux Arts d'Algérie. She moved to Paris as a teenager and earned a diploma from the Ecole Nationale Supérieure d'Arts de Cergy-Paris in 2002. Bouabdellah was the spring 2008 Amherst College Artist in Residence. Her work was included in* Global Feminisms: New Directions in Contemporary Art. *She currently lives and works in Aubervilliers, France, outside Paris and is represented by La B.A.N.K. Gallery, Paris.*

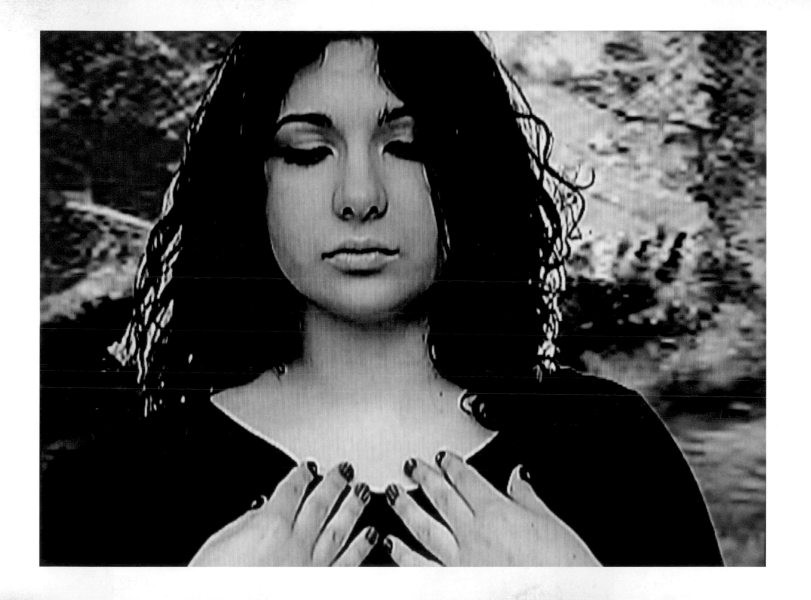

KENNETH TIN-KIN HUNG

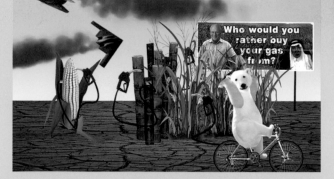

fig. 29 **Kenneth Tin-Kin Hung** *Gas Zappers*, 2007 / Music by Noah Vawter
HD video, 5 minutes / Edition of 5 +AP
Courtesy of Postmasters Gallery, New York, NY

Kenneth Tin-Kin Hung is the John Heartfield of the digital era. His biting satire takes on big issues like global warming (fig. 29) and the hotly contested 2008 U.S. Presidential election (figs. 30 and 31) in "pop-up" sculptures of the current political landscape. Hung's raucously funny digital montages (whether printed on canvas, on Foamcor, or as video-game parodies) are composed entirely of imagery appropriated from Internet sources combined into provocative caricatures of America's current role in global politics, as seen by a 20-something-year-old. The often-outrageous juxtapositions in Hung's montages jolt viewers to see familiar media images in new contexts. Whether his work is a time capsule of the early 21st century or a critique of globalization, capitalism, and democracy as the current guises of Empire is open to debate. Hung ensures that the debate will be a provocative one.

— A.I.S.

Kenneth Tin-Kin Hung *was born in Hong Kong in 1980. He earned his B.A. from San Francisco State University in 2001. In 2007, Hung received the Media Arts fellowship from Renew Media, sponsored by the Rockefeller Foundation. His work has been shown at Postmasters Gallery; the New Museum, New York; and the Seoul International Film Festival and the Sundance Film Festival, among numerous other festivals. He is represented by Postmasters Gallery, New York and lives and works in New York.*

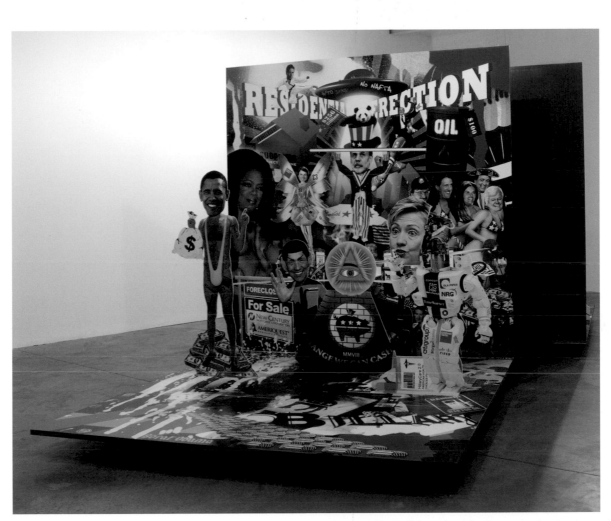

fig. 30 **Kenneth Tin-Kin Hung** *Ultra Donkey (Residential Erection: Pop-up Democrats)*, 2008
Pop-up book, installation view
Mixed media (wood/foam panel, digital print on paper) / 8 x 8 x 8 feet
Courtesy of Postmasters Gallery, New York, NY

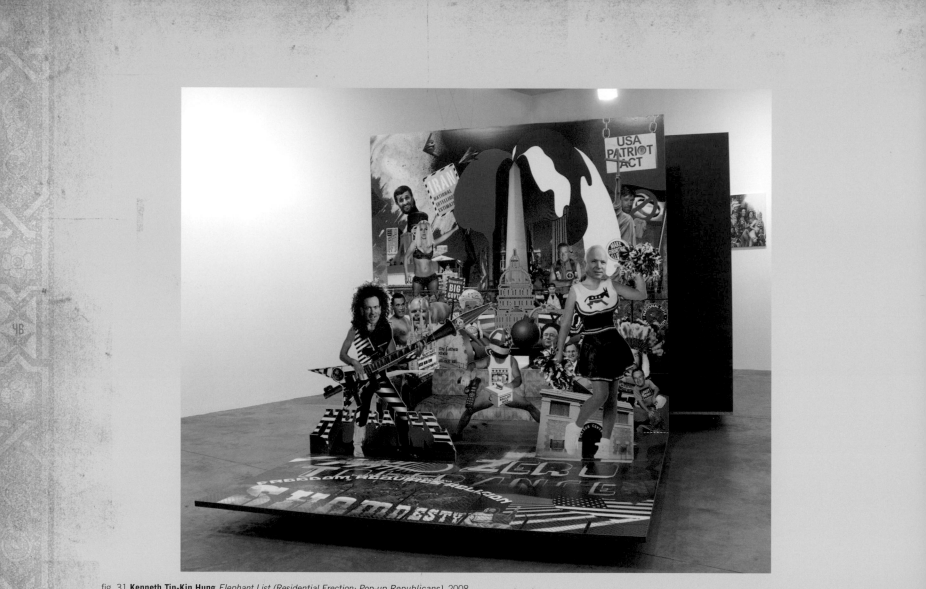

fig. 31 **Kenneth Tin-Kin Hung** *Elephant List (Residential Erection: Pop-up Republicans)*, 2008
Pop-up book, installation view
Mixed media (wood/foam panel, digital print on paper)
8 x 8 x 8 feet / Courtesy of Postmasters Gallery, New York, NY

FARHAD MOSHIRI/SHIRIN ALIABADI

Farhad Moshiri and Shirin Aliabadi's series of brash photographic prints, titled *Supermarket*, re-brand and re-present recognizable commodities like cleaning products, brand-name chocolates, and breakfast cereal as advertisements or hyperrealist still-life paintings. The product labels have been altered to convey the not-so-subliminal message that these commodities are signifiers of the global economy, which in at least one photograph, *We Are All Americans* (fig. 6), is typed as U.S.-dominated. (Perhaps it is no accident that these neatly displayed products all pertain to cleaning house?) Other works in the series such as *Tolerating Intolerance* (fig. 36), *People Killing People* (fig. 35), and *Families Ask Why* (fig. 33) also simulate the language of advertising but have more open-ended messages that refer obliquely to protracted conflicts in the Middle East. In these instances, sweet confections pack a punch. *You Are The Fearless Rose* (fig. 34) sounds like a slogan for martyrdom.

Moshiri and Aliabadi's photographic series does not suggest a diverse world of products or ideas, but a more limited range. What does the term "supermarket" refer to, then? Perhaps the global marketplace of ideas has been so skewed by media sources that they themselves have become a new form of Empire?

— *A.I.S.*

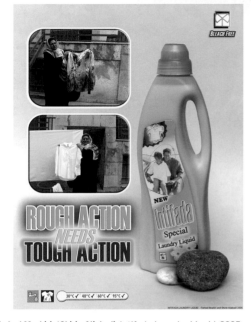

fig. 32 **Farhad Moshiri** / **Shirin Aliabadi** *Intifada Laundry Liquid*, 2005
Lambda print / 39 ³/₅ x 29 ¹/₂ inches
Courtesy of Daneyal Mahmood Gallery, New York, NY

49

Farhad Moshiri *was born in Shiraz, Iran in 1963 and graduated from the California Institute of the Arts in Valencia in 1984. He recently exhibited at Galerie Rodolphe Janssen, Brussels; Daneyal Mahmood Gallery, New York; Dar ar Fonoon Gallery, Kuwait; the Third Line Gallery, Dubai; and the Kashya Hildebrand Gallery, New York/Geneva/Zurich; Tallinn Kunsthalle, Estonia; the Sharjah Biennial, United Arab Emirates; and Tehran Gallery, University of Tehran. His work is represented by Daneyal Mahmood Gallery, New York and Galerie Emmanuel Perrotin, Paris/Miami. Moshiri collaborates periodically with artist* **Shirin Aliabadi** *(b. 1973). Moshiri and Aliabadi live and work in Tehran, Iran.*

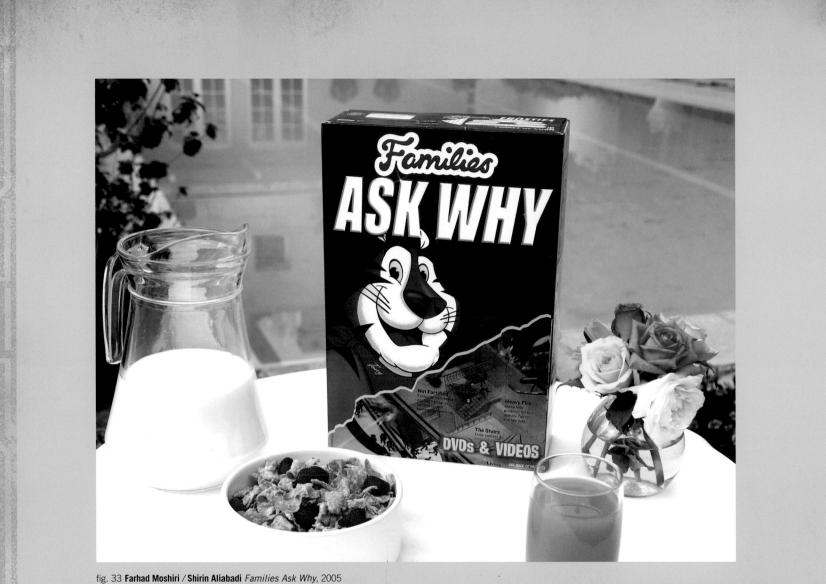

fig. 33 **Farhad Moshiri / Shirin Aliabadi** *Families Ask Why*, 2005
Lambda print / 29 ¹/₅ x 39 ³/₅ inches
Courtesy of Daneyal Mahmood Gallery, New York, NY

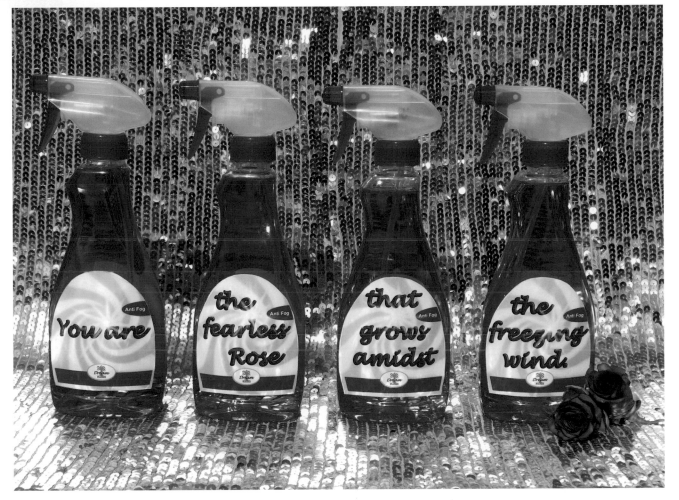

fig. 34 **Farhad Moshiri / Shirin Aliabadi** *You are the Fearless Rose*, 2005
Lambda print / 29 ¹/₂ x 39 ³/₅ inches
Courtesy of Daneyal Mahmood Gallery, New York, NY

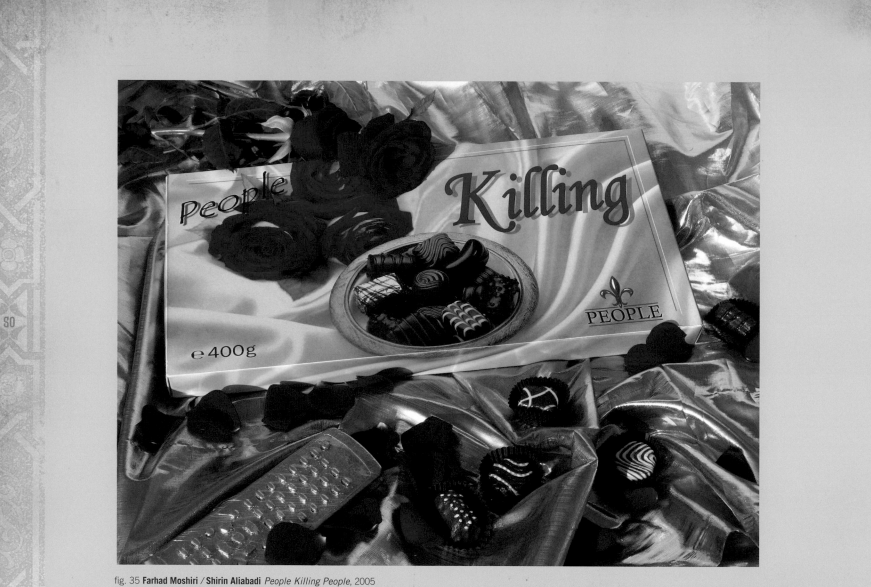

fig. 35 **Farhad Moshiri** / **Shirin Aliabadi** *People Killing People*, 2005
Lambda print / 29 $\frac{1}{2}$ x 39 $\frac{3}{5}$ inches
Courtesy of Daneyal Mahmood Gallery, New York, NY

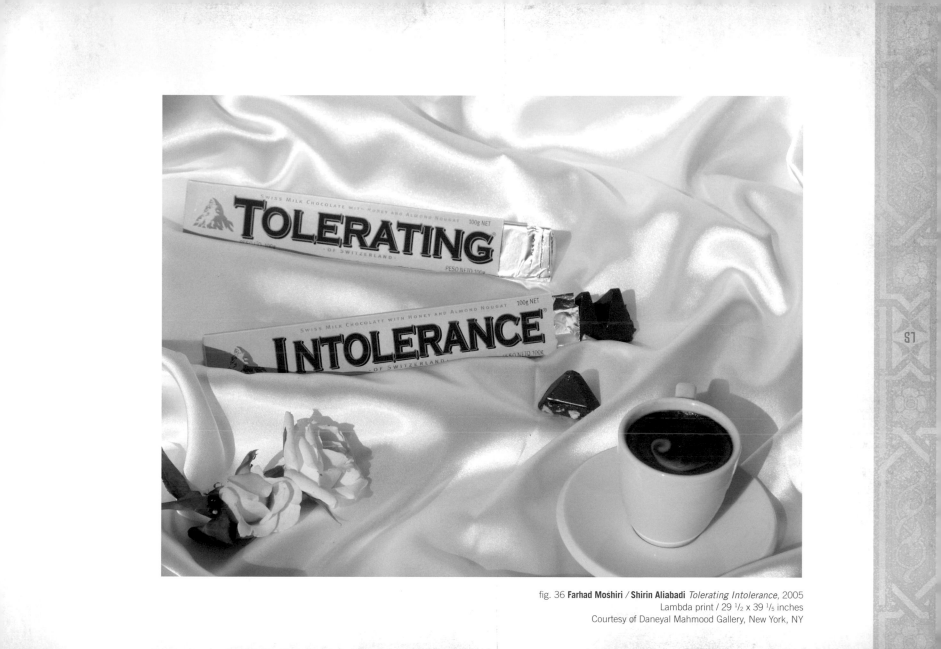

fig. 36 **Farhad Moshiri / Shirin Aliabadi** *Tolerating Intolerance*, 2005
Lambda print / 29 $^1/_2$ x 39 $^1/_5$ inches
Courtesy of Daneyal Mahmood Gallery, New York, NY

MARJANE SATRAPI

Iranian graphic novelist Marjane Satrapi has become well known recently for her two-part coming-of-age books, *Persepolis: The Story of A Childhood* and *Persepolis 2: The Story of A Return*, and the animated film version of these books. Published when the artist was in her mid-30s, they are candid autobiographical memoirs that poignantly chart in graphic novel form the history of Iran during the 1970s through 1990s from an irreverent child's perspective. The passages and pages selected here reference the comings-and-goings of empires, the famous pride of the Persian people (as different from Arab peoples), the folly of ideological positions such as anarchism and communism, and the disregard for the socially marginalized in western (European) liberal democracies. The character Marjane is jaded and unbelievably precocious, believing in God and Karl Marx at the same time, whereas the author Satrapi's political positions are unclear;

neither seems pro-western nor pro-Iranian. A closeted Christian girl in an Islamic theocracy, a freakish French-speaking, teenage outsider in Austria, a "western slut" to her adult Iranian friends, Marjane is not so much an outsider as an "in-betweener." Satrapi–the character and author–pokes fun at the pomp and circumstance bolstering Empires of all sorts, decries the passivity of intellectuals who aren't also activists, and rails against the cult of martyrdom. She is the cosmopolitan figure perhaps closest in character to Edward Said in this exhibition.

— A.I.S.

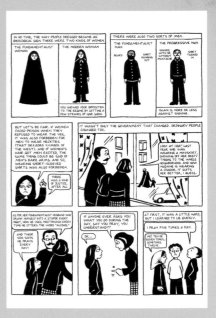

figs. 37 and 38 **Marjane Satrapi**
From *Persepolis: The Story of A Childhood*
by Marjane Satrapi, translated by Mattias Ripa
and Blake Ferris, pages 75 and 102

Marjane Satrapi *was born in Rasht, Iran in 1969, and currently lives in Paris. She grew up in Tehran, where she studied at the Lycée Français before leaving for Vienna and then going to Strasbourg to study illustration. Her graphic novels* Persepolis *and* Persepolis 2 *depict her experience growing up in Iran and Europe before, during, and after the Iranian Revolution.*

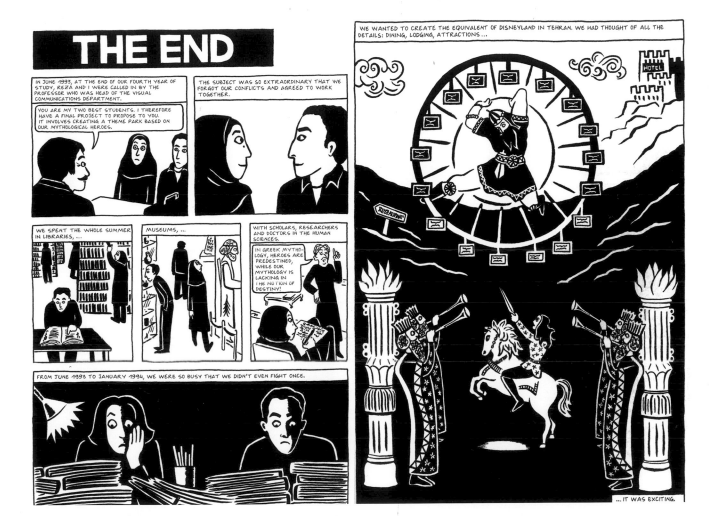

figs. 39 and 40 **Marjane Satrapi**
From *Persepolis 2: The Story of A Return*
by Marjane Satrapi, translated by Anjali Singh
pages 174-175

SEHER SHAH

Seher Shah's most recent series of giclée prints *Perversions of Empire* offer dense, layered "reconstructions" of pop imagery, personal travel photography, colonial imagery culled from the Royal Geographic Society Archives in London, media images, and hand-drawn imagery. In this series, Shah is particularly interested in the symbolism of monuments as "relics of colonial Eurocentric authority" that continue to function as place markers and points of reference in contemporary, post-colonial urban design. For her, monuments are central to creating grandiose, collective symbols of authority around which the masses gravitate for the spectacles that constitute the very essence of Empire. Though much of her source material references colonial and post-colonial India and the partition of Pakistan, Shah is not interested in investigating a

"geographical territorial study." Rather, Empire–for her a "contemporary state of hegemony"–is the manifestation of authority and dominance and is expressed through forms of monuments, architecture, and the "Eurocentric geometries" of urban planning. Shah questions "how much of Empire comes through in us collectively?"

Like Kamrooz Aram, Seher Shah was influenced by *Orientalism* at a formative stage in her western education in Providence, RI. She regards "the language of defined geographies" and dichotomies like East and West, Orient and Occident as "extremely problematic." "Being born in Pakistan and moving to London, Brussels, and New York, whilst traveling back and forth left me a fairly fluid and unified sense of cultures and movement," she says. Shah is interested in Said's notions of historical inventory and of "lines of coexistence and counterpoint." Her dense compositions are characterized by a Saidian sense of counterpoint– of multiple, coexisting narratives– layered and scaled from differing vantage points. She hopes that viewers will reconstruct for themselves the symbols loaded into each image, weaving their own connections between old and new, east and west, pagan and religious traditions, and colonial and post-colonial spaces, and, in doing so, she hopes that "the grandiose schemes of Empire will unravel."

— A.I.S.

Seher Shah *was born in Karachi, Pakistan, in 1975 and grew up in the United Kingdom, Belgium, and New York. She received her BFA and Bachelor of Architecture from the Rhode Island School of Design in 1998. Most recently, she has shown at the Queens Museum of Art and the Bose Pacia Gallery in New York. She currently lives and works in Brooklyn, New York.*

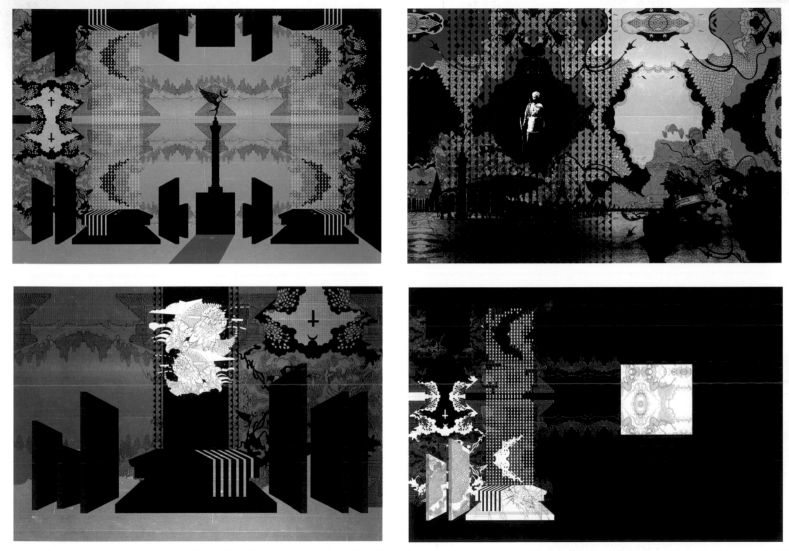

fig. 41 **Sheher Shah** *Perversions of Empire: Cluster,* 2008 / Archival giclée prints / Edition of 10 / 8 frames, 18 x 24 inches each / Courtesy of the Shumita and Arani Bose Collection, New York, NY

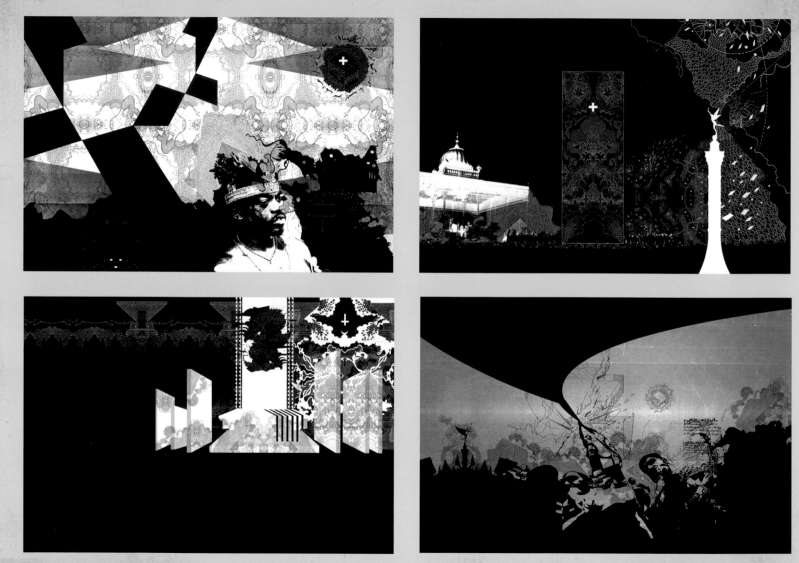

Sheher Shah *Perversions of Empire: Cluster*

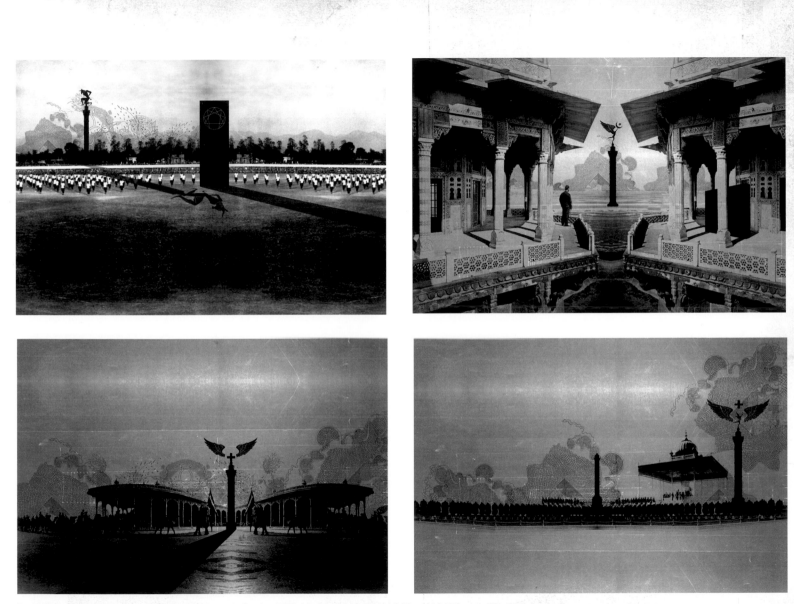

fig. 42 **Seher Shah** *Perversions of Empire: The Concrete Oracles,* 2008 / Archival giclée prints / Edition of 10 / 8 frames, 18 x 24 inches each
Courtesy of the Shumita and Arani Bose Collection, New York, NY

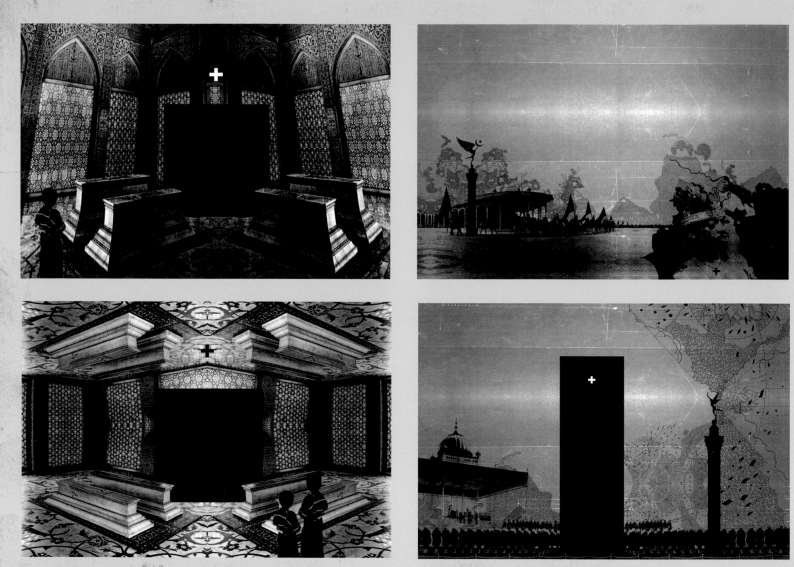

Seher Shah *Perversions of Empire: The Concrete Oracles*

MARK SHETABI

Mark Shetabi's installation *A Persian Garden* was conceived as a "vault" of personal and historical memory. The paintings and sculpture contained inside the 14 x 20-foot room all relate to the cusp between the end of the reign of the last Shah of Iran and the 1979 Iranian Revolution, upon which the Islamic Republic of Iran was founded—the end of one empire and the beginning of a new regime. The nondescript, anonymous feel of the space reflects the ubiquitous modernist architectural forms in Tehran in the mid-1970s (one of the artist's most vivid memories of the city, the two homes in which he lived, and the Terhan American School). The illuminated drop ceiling suggests an enlarged reliquary, and the flooring and textured walls suggest an interior courtyard reminiscent of the "garden" at the center of the room.

The strangely interlocking geometric forms of the courtyard's pools were designed by the artist from memory and then fabricated as an architectural model. For Shetabi, ordinary things take on qualities of the extraordinary, when they are the locus of specific, charged memories.

In much of Shetabi's work the act of observing is challenging for the viewer because the vantage point offered is uncomfortably low or high, partially blocked, or distorted by a concave peephole lens, through which one is forced to look. In *A Persian Garden*, the artist embraces a bird's-eye perspective, particularly in looking down upon the model of his childhood courtyard, which he thinks of as a "God's eye/surveillance/satellite view" used prominently in the work of Pieter Breughel and Andreas Gursky, among other artists. For Shetabi, as for Michel Foucault, the act of looking is never neutral

During the Shah's reign, western, modernist forms were very important signifiers of progress in the country. *Thin Ice* and *Caspian Sea Hilton* (fig. 3) depict views of the interiors of swanky American style hotels that were built throughout the country in the 1970's. Many of these spaces were very aggressively Modernist in their design and made use of vaguely Utopian ideas about what the future was supposed to look like. The futuristic look of many of these spaces has now become a period style.— M.S.

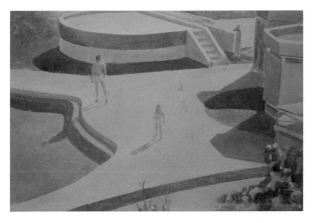

fig. 43 **Mark Shetabi**
Thin Ice, 2008
Oil on linen
22 x 32 inches
Courtesy of the artist
and Jeff Bailey Gallery,
New York

and always constitutive of power relationships. But this vantage point from above looking down also implies the passage of time and distance from one's past that can distort one's memory. In this installation, the artist grapples with his desire to represent, and hence to master, his innocent, childhood memories and to put them into some larger, political context while also reversing the Occidental gaze that nostalgically witnessed the collapse of the Persian Empire.

— A.I.S.

Mark Shetabi *was born in 1970 in Mineola, NY and lived in Iran from 1974 to 1978. He received his B.A. from Walla Walla University in Bellingham, WA and his MFA in painting from the Pennsylvania Academy of Fine Arts. He has exhibited at Locks Gallery, Philadelphia; White Columns, New York; Ratio 3, San Francisco; and Jeff Bailey Gallery, New York, which represents him. He received a Pew Fellowship in the Arts in 2002. Shetabi teaches at the Tyler School of Art, Temple University and lives and works in Philadelphia, PA.*

figs. 44 and 45 **Mark Shetabi**
A Persian Garden, 2008
Sculpture/model / 3 x 4 feet
Courtesy of the artist and
Jeff Bailey Gallery, New York

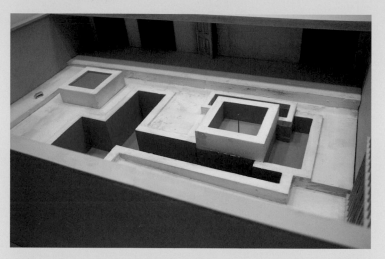

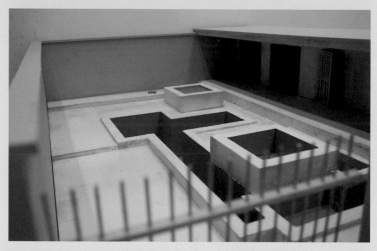

This is a model of the backyard of the house were I lived from 1974-1977.
The model acts as a kind of locus around which the painted images swirl. — M.S.

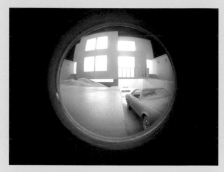

fig. 46 **Mark Shetabi**
The Palace @ 4AM, 2003
MDF, balsa wood, acrylic, Plexiglas, Mylar,
sand, styrene, aluminum, felt, halogen lights,
and peephole lens / dimensions variable
Courtesy of the artist and
Jeff Bailey Gallery, New York

Interior view through door peephole of *The Palace at 4AM*.
This is a reconstruction of my childhood home in Tehran,
Iran and was built entirely from memory. It was an initially
disconcerting revelation to realize that this house, which is
the locus of so many specific memories of Iran, is a rather
anonymous example of late – period international modernist
architecture. Its design indicates nothing of its context, and
could be found in any contemporary cosmopolitan center.
But my memories don't see it that way. In my memory, it
is late 1978, and the house is blazing with light. We are
packing to move back to the United States. — M.S.

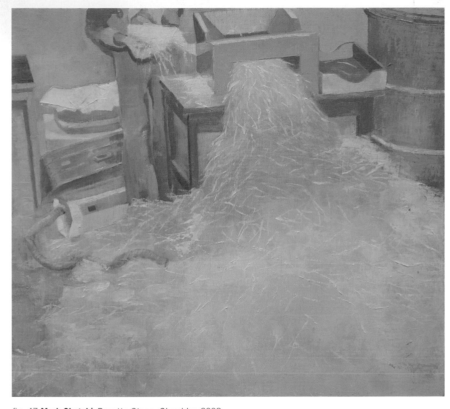

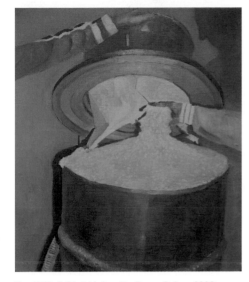

fig. 48 **Mark Shetabi** *Rosetta Stone–Pulper*, 2008
Oil on linen / 14 x 12 inches
Courtesy of the artist and Jeff Bailey Gallery, New York

fig. 47 **Mark Shetabi** *Rosetta Stone–Shredder*, 2008
Oil on linen mounted panel / 18 x 20 inches
Courtesy of the artist and Jeff Bailey Gallery, New York

When the Iranian students took over the U.S. Embassy in 1979, they stumbled on one of the largest CIA stations in the world. Embassy staff was in the process of frantically shredding sensitive documents. These shreds would then put into a pulper, where they were definitively destroyed. As it turned out, many of the documents were not pulped, and over the next 2 years, the Iranians were able to laboriously piece the shreds together and published the findings, leading to one of the largest intelligence breaches in U.S. history. *Rosetta Stone* refers to a breakthrough moment of revealing information. The original Rosetta stone revealed secrets of the Orient to the Occidental or Western world. The documents pieced together by the Iranians revealed secrets of the Occident to the Orient.—M.S.

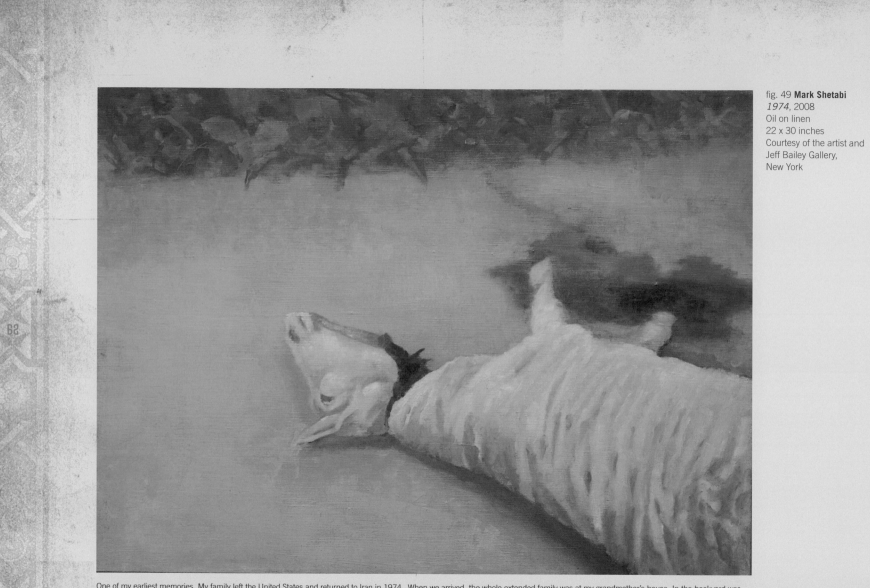

fig. 49 **Mark Shetabi**
1974, 2008
Oil on linen
22 x 30 inches
Courtesy of the artist and
Jeff Bailey Gallery,
New York

One of my earliest memories. My family left the United States and returned to Iran in 1974. When we arrived, the whole extended family was at my grandmother's house. In the backyard was a cute lamb tethered to a stake. A little while later, the lamb was slaughtered to celebrate our arrival. I watched as the red blood flowed into a flowerbed, out of which red flowers grew. It was the most startling thing I had ever seen. An epiphany. My first color memory.—M.S.

SAIRA WASIM

Saira Wasim ingeniously subverts Mughal miniature painting, a tradition in which she was trained in Lahore, Pakistan, to depict contemporary world politics as a stage on which actors are engaged in epic struggles frozen in time. Identifiable current world leaders like George W. Bush, Condoleezza Rice, Hosni Mubarak, Mahmood Ahmadinejad, and Pervez Musharraf stand in for their countries while symbols of American cultural imperialism like Ronald McDonald and Coca-Cola are animated alongside allegorical animals. Like Kamrooz Aram's ink drawings and Andisheh Avini's marquetry-covered symbolic objects, which also employ masterful draughtsmanship or craftsmanship, Wasim's gouache miniatures pay homage to her heritage while redirecting their content to a critique of the present, rather than a dialogue with history. Wasim's paintings blend Eastern technique and contemporary content from her vantage point in the West; they are neither pro-eastern nor pro-western; neither Orientalist nor Occidentalist.

A good example of Wasim's syncretic position is *The Passion Cycle II* (fig. 50). The white drapery worn by dead and dying male martyrs forms a mass around a central brown circle containing a textual passage in Urdu. The circular composition of pale flesh and white drapery contrasts dramatically with dark pools of blood and brown background. Each of the ten male figures is a distinct study in the expression of pathos derived from (western) Medieval and Renaissance paintings of martyred saints. In the contemporary context, martyrdom has been associated with Muslims rather than Christians. Wasim's painting dislodges those associations; her martyrs are individuals represented in a dignified manner. Given that Wasim's personal relationship with

Islam is fraught (her family are members of a Muslim minority sect, the Ahmadis, and were persecuted in Pakistan as non-Muslim), *The Passion Cycle II* eschews stereotypical representation (though she does partake in her fair share of type-casting in other paintings). The composition, depicted from above, clearly conveys the message, however, that the "cycle of passion" creating a cult of martyrdom is a perpetual cycle of violence with no positive gain or end.

— A.I.S.

Saira Wasim *was born in Lahore, Pakistan in 1975 and received her BFA at the National College of Arts in Lahore in 1999. Actively exhibiting since 2000, her work was included in the traveling exhibition* One Way or Another: Asian American Art Now, *organized by the Asia Society and Museum, New York, and in* The American Effect: Global Perspectives on the United States, 1990-2003 *at the Whitney Museum of American Art in 2003. Wasim's work is in the collections of the Fukuoka Asian Art Museum, Japan; the Victoria and Albert Museum, London; the Smith College Museum of Art; and many private collections. She is represented by Ameringer and Yohe Fine Art, New York. The artist lives and works in Chicago, IL.*

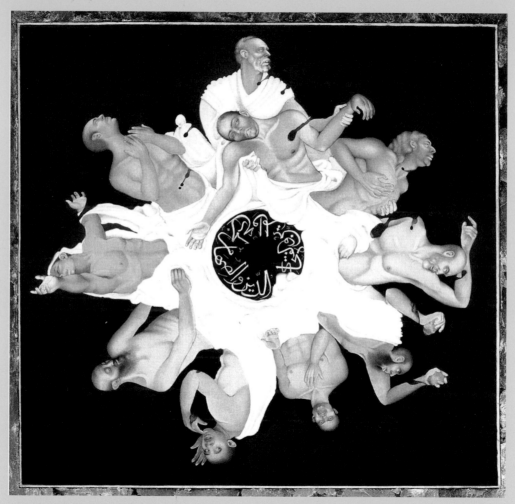

fig. 50 **Saira Wasim** *The Passion Cycle II,* 2007
Gouache, ink, and silver leaf on wasli paper / 10 x 10 inches
The Anwar Family Collection, London
Courtesy of Ameringer & Yohe Fine Art, New York, NY

fig. 51 **Saira Wasim** *Demockery* 2008
Gouache, gold, gold leaf, and tea washes on wasli paper
10 ¾ x 18 ¹/₁₆ inches
Private Collection, New York, NY
Courtesy of Ameringer & Yohe Fine Art, New York, NY

fig. 52 **Saira Wasim** *Whose War Is It Anyway*, 2007
Gouache, ink, gold, and tea washes on wasli paper / 11 ½ x 8 ¾ inches
Private Collection, Houston / Courtesy of Ameringer & Yohe Fine Art, New York, NY

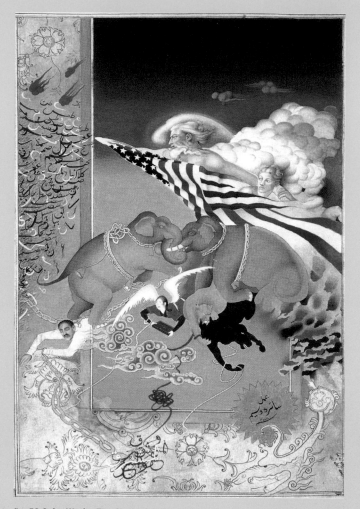

fig. 53 **Saira Wasim** *The Clash of Civilizations* 2007
Gouache, gold, and gold leaf on wasli paper / 24 ¼ x 18 ½ inches
Collection of Koli Banik and Erik Bertin, Alexandria, VA
Courtesy of Ameringer & Yohe Fine Art, New York, NY

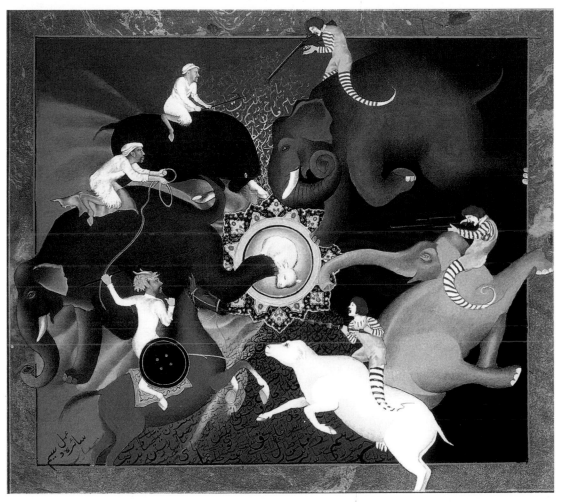

fig. 54 **Saira Wasim**
East Versus West, 2007
Gouache on wasli paper
16 x 17 5/16 inches
Collection of Deborah and
Peter Smith
Courtesy of Ameringer &
Yohe Fine Art, New York, NY

Figure of a Good Genius, Pasargadae

EXHIBITION CHECKLIST

Kamrooz Aram

From the series Irrational Exuberance, 2007
Pen on paper
14 ½ x 10 ½ inches
Courtesy of the artist and
Perry Rubenstein Gallery, New York, NY

From the series Revolutionary Dreams, 2007
Ink and collage on paper
13 x 10 ½ inches
Courtesy of the artist and
Perry Rubenstein Gallery, New York, NY

From the series Revolutionary Dreams, 2007
Pen on paper
44 x 30 ¼ inches
The Sender Collection, New York, NY
Image courtesy of the artist and
Perry Rubenstein Gallery, New York, NY

*From the series Mystical Visions and Cosmic
Vibrations to the series Revolutionary Dreams,*
2007
Ink on paper
14 ¾ x 18 ¾ inches
Courtesy of the artist and
Perry Rubenstein Gallery, New York, NY

*From the series Revolutionary Dreams to
the series Mystical Visions and Cosmic
Vibrations (and back again), or Radical Shia
Cleric, or Spiritual Leader,* 2008
Ink on paper
41 ½ x 30 ½ inches
Collection of Ikkan Sanada, New York, NY
Image courtesy of the artist and
Perry Rubenstein Gallery, New York, NY

*Mystical Visions Undetected by Night
Vision Strengthen the Faith of the Believers
and Make Their Enemies Scatter II,* 2007
Oil and collage on canvas
73 x 113 inches
The Sender Collection, New York, NY
Image courtesy of the artist and
Perry Rubenstein Gallery, New York, NY

Andisheh Avini

Homesick, 2007
Plaster and Khataam (marquetry)
20 x 5 x 5 inches
Courtesy of the artist and I-20 Gallery,
New York, NY

Untitled, 2007
Gold leaf and inkjet print on paper
mounted to wood
Triptych, 14 ¼ x 21 inches each
Courtesy of the artist and I-20 Gallery,
New York, NY

Untitled, 2007
Paper collage
30 x 22 ¾ inches
Courtesy of the artist and I-20 Gallery,
New York, NY

Untitled, 2007
Plastic skull and Khataam (marquetry)
6 x 9 x 5 inches
Courtesy of the Collection of
Beth Rudin DeWoody

Untitled, 2008
Paper collage, acrylic, gold leaf, and plastic
24 x 17 x 12 inches
Courtesy of the artist and I-20 Gallery,
New York, NY

Untitled (I), 2006
Bleach, gold leaf, and inkjet print on canvas
38 ¾ x 56 ¾ inches
Courtesy of the artist and I-20 Gallery,
New York, NY

Untitled (II), 2006
Bleach, gold leaf, and inkjet print on canvas
46 ¾ x 26 ¾ inches
Courtesy of the artist and I-20 Gallery,
New York, NY

Untitled (V), 2006
Bleach, gold leaf, and inkjet print on canvas
45 ½ x 29 inches
Courtesy of the artist and I-20 Gallery,
New York, NY

Untitled (XXIX), 2005
Inkjet print and acrylic on paper
8 ½ x 11 inches
Courtesy of the artist and I-20 Gallery,
New York, NY

Lara Baladi
Surface of Time, 2004-2007
Permanent pigment print on Somerset paper
Eight diptychs, 19 ³/₁₆ x 29 ½ inches each
Courtesy of the artist

Zoulikha Bouabdellah
Black and White #2, 2008
Video, 6 minutes, 25 seconds
Courtesy of the artist and La B.A.N.K.
Gallery, Paris

Kenneth Tin-Kin Hung
Gas Zappers, 2007
Music by Noah Vawter
HD video, 5 minutes
Edition of 5 +AP
Courtesy of Postmasters Gallery, New York, NY

*Elephant List (Residential Erection: Pop-up
Republicans),* 2008
Pop-up book, installation view
Mixed media (wood/foam panel,
digital print on paper)
8 x 8 x 8 feet
Courtesy of Postmasters Gallery, New York, NY

*Ultra Donkey (Residential Erection: Pop-up
Democrats),* 2008
Pop-up book, installation view
Mixed media (wood/foam panel,
digital print on paper)
8 x 8 x 8 feet
Courtesy of Postmasters Gallery, New York, NY

Farhad Moshiri and Shirin Aliabadi
Families Ask Why, 2005
Lambda print
29 ¹/₂ x 39 ³/₅ inches
Courtesy of Daneyal Mahmood Gallery,
New York, NY

Intifada Laundry Liquid, 2005
Lambda print
39 ³/₅ x 29 ¹/₂ inches
Courtesy of Daneyal Mahmood Gallery,
New York, NY

People Killing People, 2005
Lambda print
29 ¹/₂ x 39 ³/₅ inches
Courtesy of Daneyal Mahmood Gallery,
New York, NY

Tolerating Intolerance, 2005
Lambda print
29 1/2 x 39 3/5 inches
Courtesy of Daneyal Mahmood Gallery,
New York, NY

We Are All Americans, 2005
Lambda print
29 1/2 x 39 3/5 inches
Courtesy of Daneyal Mahmood Gallery,
New York, NY

You are the Fearless Rose, 2005
Lambda print
29 1/2 x 39 3/5 inches
Courtesy of Daneyal Mahmood Gallery,
New York, NY

Marjane Satrapi
Persepolis: The Story of A Childhood
by Marjane Satrapi, translated by
Mattias Ripa and Blake Ferris
Persepolis 2: The Story of A Return
by Marjane Satrapi, translated by Anjali Singh

Scher Shah
Perversions of Empire: Cluster, 2008
Archival giclée prints
Edition of 10
8 frames, 18 x 24 inches each
Courtesy of Shumita and
Arani Bose Collection, New York, NY

Perversions of Empire:
The Concrete Oracles, 2008
Archival giclée prints
Edition of 10
8 frames, 18 x 24 inches each
Courtesy of Shumita and
Arani Bose Collection, New York, NY

Mark Shetabi
A Persian Garden, 2008
MDF, acrylic, marble dust, aluminum,
plexiglass, balsa wood
Installation, 14 x 20 feet
Courtesy of the artist and
Jeff Bailey Gallery, New York
(installation not illustrated)

A Persian Garden, 2008
Sculpture/model
3 x 4 feet
Courtesy of the artist and
Jeff Bailey Gallery, New York

1974, 2008
Oil on linen
22 x 30 inches
Courtesy of the artist and
Jeff Bailey Gallery, New York

Caspian Sea Hilton, 2008
Oil on linen
22 x 30 inches
Courtesy of the artist and
Jeff Bailey Gallery, New York

Rosetta Stone–Pulper, 2008
Oil on linen
14 x 12 inches
Courtesy of the artist and
Jeff Bailey Gallery, New York

Rosetta Stone–Shredder, 2008
Oil on linen mounted panel
18 x 20 inches
Courtesy of the artist and
Jeff Bailey Gallery, New York

Thin Ice, 2008
Oil on linen
22 x 32 inches
Courtesy of the artist and
Jeff Bailey Gallery, New York

Saira Wasim
The Clash of Civilizations, 2007
Gouache, gold, and gold leaf on wasli paper
24 1/4 x 18 1/2 inches
Collection of Koli Banik and Erik Bertin,
Alexandria, VA
Courtesy of Ameringer & Yohe Fine Art,
New York, NY

Demockery, 2008
Gouache, gold, gold leaf, and tea washes
on wasli paper
10 3/4 x 18 1/16 inches
Private Collection, New York, NY
Courtesy of Ameringer & Yohe Fine Art,
New York, NY

East Versus West, 2007
Gouache on wasli paper
16 x 17 5/16 inches
Collection of Deborah and Peter Smith
Courtesy of Ameringer & Yohe Fine Art,
New York, NY

The Passion Cycle II, 2007
Gouache, ink, and silver leaf on wasli paper
10 x 10 inches
The Anwar Family Collection, London
Courtesy of Ameringer & Yohe Fine Art,
New York, NY

Round Table, 2005
Gouache, gold leaf, and ink on tea stained
wasli paper
17 x 18 inches
The Anwar Family Collection, London
Courtesy of Ameringer & Yohe Fine Art,
New York, NY

Whose War Is It Anyway, 2007
Gouache, ink, gold, and tea washes
on wasli paper
11 1/2 x 8 3/4 inches
Private Collection, Houston
Courtesy of Ameringer & Yohe Fine Art,
New York, NY

"SOVEREIGNTY HAS TAKEN A NEW FORM,
COMPOSED OF A SERIES OF NATIONAL AND SUPRANATIONAL
ORGANISMS UNITED UNDER A SINGLE LOGIC OF RULE.
THIS NEW GLOBAL FORM OF SOVEREIGNTY IS
WHAT WE CALL EMPIRE." —*Michael Hardt and Antonio Negri, Empire*

"THE VERY WORD EMPIRE. . . HAS HAD A COMPLICATED HISTORY AND MANY DIFFERENT, FIERCELY CONTESTED MEANINGS. IT HAS ALSO BEEN INTERTWINED WITH SEVERAL OTHER, MOSTLY NEWER BUT EQUALLY CONTENTIOUS WORDS: IMPERIALISM, COLONIALISM, AND LATTERLY NEOCOLONIALISM, GLOBALIZATION, AND OTHERS. . . THE DIFFICULTIES INVOLVED ARE NOT JUST CONCEPTUAL AND POLITICAL BUT EMOTIONAL."

—Stephen Howe, Empire. A Very Short Introduction

SOURCES CITED

Abernethy, David B. *The Dynamics of Global Dominance: European Overseas Empires 1415-1908*. New Haven; London: Yale University Press, 2000.

Alcock, Susan E., et al, eds. *Empires: Perspectives from Archaeology and History*. New York, Cambridge: Cambridge University Press, 2001.

Ali, Tariq. *Conversations with Edward Said*. New York: Seagull Books, 2006.

Anderson, Benedict. *Imagined Communities*. London: Verso Books, 1991.

Cleveland, William L. *A History of the Modern Middle East*. Third Ed., Boulder: Westview Press, 2004.

Doyle, Michael W. *Empires*. Ithaca: Cornell University Press, 1986.

Elkins, James, ed. *Is Art History Global?* New York; London: Routledge, 2006.

Fernandez, Maria. "Postcolonial Media Theory." In *The Feminism and Visual Culture Reader*, 520-528. London; New York: Routledge, 2003.

Hardt, Michael and Antonio Negri. *Empire.* Cambridge: Harvard University Press, 2000.

Hobsbawm, Eric and Terence Ranger, eds. *The Invention of Tradition*. Cambridge: Cambridge University Press, 1983.

Hodgson, Marshall G. S. *The Venture of Islam: Conscience and History in a World Civilization. Volume III. The Gunpowder Empires and Modern Times.* Chicago; London: The University of Chicago Press, 1974.

Howe, Stephen. *Empire. A Very Short Introduction.* New York: Oxford University Press, 2002.

Nochlin, Linda. "The Imaginary Orient." In *The Politics of Vision*, 33-59. New York: Harper & Row, 1989.

Rosenfield, John M. *The Dynastic Arts of the Kushans.* Berkeley; Los Angeles: University of California Press, 1967.

Said, Edward W. *Culture and Imperialism.* 1st ed., New York: A.A. Knopf, 1993.

_____. *Orientalism.* New York: Vintage Books, 1979.

_____. "Orientalism Reconsidered." *Race & Class* 27, no. 2 (Autumn, 1985): 1-15.

Satrapi, Marjane. *Persepolis: The Story of a Childhood.* New York: Pantheon Books, 2004.

Satrapi, Marjane. *Persepolis 2: The Story of a Return.* New York: Pantheon Books, 2005.